Gardens of
North Carolina

A TRAVELER'S GUIDE

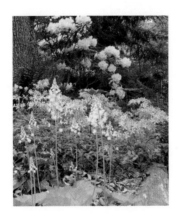

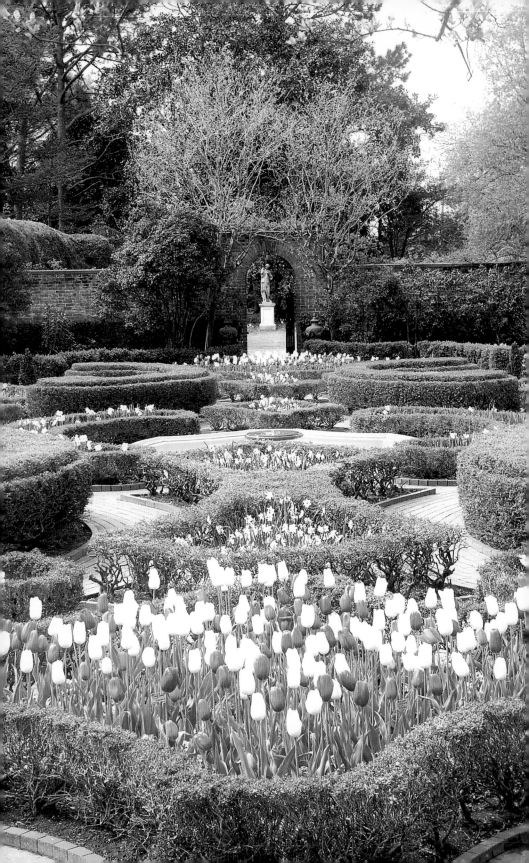

Gardens of North Carolina

A TRAVELER'S GUIDE

PETER LOEWER

STACKPOLE
BOOKS

Published by
STACKPOLE BOOKS
5067 Ritter Road
Mechanicsburg, PA 17055
www.stackpolebooks.com

Printed in China

10 9 8 7 6 5 4 3 2 1

FIRST EDITION

Design by Beth Oberholtzer
Cover design by Caroline Stover

Photos by the author unless otherwise noted

Cover: The Quilt Garden at the North Carolina Arboretum in Asheville is planted with blooming annuals a number of times during the garden year.

Page i: Spring wildflowers including foamflowers, phlox, and rhododendrons bloom in the glen at the UNCC Gardens at Charlotte. LARRY MELLINCHAMP

Page ii: The Latham Garden in a glorious salute to spring at the home of North Carolina's royal governor William Tryon. TRYON GARDENS

Page viii: The color walk at the Daniel Stowe Botanical Garden offers a shaded retreat from the noonday sun. MIKE BUSH

Library of Congress Cataloging-in-Publication Data

Loewer, H. Peter.
 Gardens of North Carolina : a traveler's guide / Peter Loewer. — 1st ed.
 p. cm.
 ISBN-13: 978-0-8117-3374-8 (pbk.)
 ISBN-10: 0-8117-3374-2 (pbk.)
 1. Gardens—North Carolina—Guidebooks. 2. North Carolina—Guidebooks. I.
Title.

SB466.U6L624 2007
712.09756—dc22

 2006039360

CONTENTS

Preface vii

Introduction ix

THE MOUNTAINS

The Biltmore Estate at Asheville 2

The Botanical Gardens at Asheville 3

Campus Arboretum of Haywood Community College 4

The Carl Sandburg Home 5

Cherokee Medicine Trail 6

Chimney Rock Park 8

Craggy Gardens 9

Daniel Boone Native Gardens 11

Grandfather Mountain 12

Highlands Biological Station 13

Joyce Kilmer Memorial Forest 15

Montreat Conference Center 16

The North Carolina Arboretum 18

Pearson's Falls 20

Richmond Hill Inn Gardens 22

Roan High Bluff Natural Gardens 23

Wilkes Community College Gardens 25

THE PIEDMONT

Bethabara Gardens	28
Blue Jay Point	29
The Calvin Jones House and the Ruth Snyder Garden	30
Cape Fear Botanical Garden	32
Coker Arboretum	33
Daniel Stowe Botanical Garden	35
Davidson Arboretum	37
Durant Park	38
Elizabeth Holmes Hurley Park	39
Ellen Mordecai Garden	40
Fearrington Village Gardens	42
Flora Macdonald Gardens	43
Greensboro Arboretum	44
Greensboro Bicentennial Garden and The Bog Garden	46
JC Raulston Arboretum	47
Juniper Level Botanic Garden	50
Memorial Garden	51
North Carolina Botanical Garden	52
Oak View Herb Garden	54
Reynolda Gardens	55
Sandhills Community College Gardens	57
Sarah P. Duke Gardens	59
Tanglewood Botanical Gardens	61
UNC Charlotte Botanical Gardens	63
Weymouth Center	65
Wing Haven Gardens	67
WRAL Azalea Gardens	69

THE COASTAL PLAIN

Airlie Gardens	72
Elizabethan Gardens	74
Orton Plantation Gardens	76
Poplar Grove	77
Tryon Palace	79
Wilson Rose Garden	81

PREFACE

In 1919 Bertram Whittier (B. W.) Wells moved to North Carolina and worked as a professor of botany at North Carolina State College (now University). He knew plants and he knew the state and in 1932 he published *The Natural Gardens of North Carolina*, a marvelous book about many of the natural plant communities of North Carolina. It was illustrated with good old black and white photos, images that showed just how many of the state's natural gardens are of such beauty and inherent design that they actually look like gardens under the care of men and women.

While many of the gardens featured in this book are creations of designers, plantsmen, horticulturists, master gardeners, and a host of volunteers, in a few cases dedicated people have taken an area of the state—Pearson's Falls and Craggy Gardens come to mind—and turned the land into very special places without having an overall blueprint to follow.

It's hoped that visiting some of the gardens in this book will inspire the reader to return home and begin a new garden or perhaps, on a great day, just go for a walk to escape the interstates, the planes overhead, and the general noise of our civilization.

Limiting the count to fifty was difficult, as new arboretums and gardens are being developed, such as the Paul J. Ciener Botanical Garden in Kernersville, the gardens at the North Carolina Zoo, the Magic Wings Butterfly House in Raleigh, and the Johnson County Community Garden in Smithfield.

Finally, I must thank my editor, Kyle Weaver at Stackpole Books, for helping me get a book like this off the ground; my wife, Jean, who always helps with getting me on the road; and my good friend Jerry Birdwell, for photographic advice and aid. The knowledge I've gained from being a contributing editor to *Carolina Gardener* magazine also was invaluable, as were the hospitality and horticultural aid I received from my good friend and gardening compatriot Pam Beck, of Wake Forest, North Carolina.

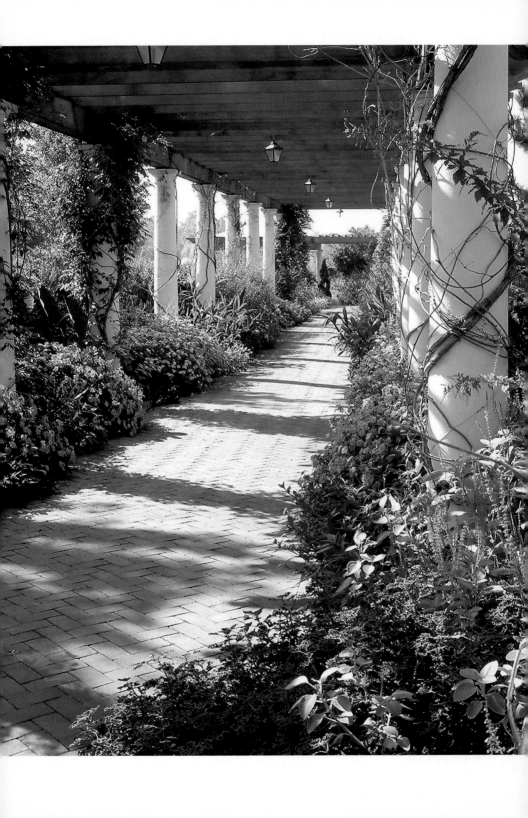

INTRODUCTION

North Carolina is very large. The state is 52,586 square miles in area and measures about 500 miles in width from Cape Hatteras on the east and Tennessee and Georgia on the west. It is about 180 miles at its widest part and narrows down to about 14 miles at the far western edge. Five interstate highways, I-40, I-26, I-77, I-85, and I-95, crisscross the state, as does U.S. Route 64, a most important road that begins at Raleigh and runs almost horizontally to Manteo and the Outer Banks.

The range of altitude in North Carolina is the greatest of any state east of the Mississippi River, beginning at sea level along the Atlantic coastline and rising up to 6,684 feet at the summit of Mount Mitchell, the highest peak in the eastern United States. Mount Mitchell lies at the heart of the Blue Ridge Mountain Range, a collection of mountains that, along with the Great Smokies, lies partly in North Carolina and partly in Tennessee, forming the highest section of the Appalachian Mountains. And going east, it's downhill from my garden to that stretch of sand washed by the Atlantic Ocean where the Wright Brothers are reported to have pulled off the first free flight in America.

Because of the range of altitudes in North Carolina, temperatures are never consistent. No matter the season, average temperatures vary more than 20 degrees Fahrenheit between the seashore and the highest mountains in the west, and at the tops of the high peaks, I sometimes have found even greater temperature variations. The average annual temperature at Mateo on the coast is almost as high as found in the interior of Florida, while the average temperature on the summit of Mount Mitchell is lower than that of Buffalo, New York—and I can testify to that, because I was born in Buffalo.

The state can be divided into three climatic regions: the Mountains, the Piedmont, and the Coastal Plain.

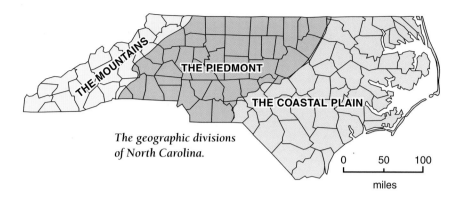

*The geographic divisions
of North Carolina.*

The Mountains

The Mountains region is the smallest of the three, about one-fifth of the state's total area. This is where I live. Here you'll find the southern part of the Appalachian Mountains, which run from the U.S. Northeast down to Georgia in the Southeast. This region has more than 125 peaks that are above 6,000 feet in height, including Mount Mitchell. The hills along the eastern edge of the mountain divide are around 1,500 feet, and some of the valleys drop to 1,000 feet above sea level. The Mountain Region is home to seventeen of the gardens listed in this book.

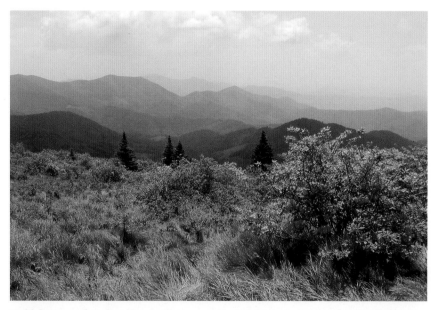

Wild flame azaleas line the meadows near Roan Mountain in Western North Carolina. JERRY BIRDWELL

Every year, tulips and pansies greet spring at the WRAL gardens in the Piedmont.
WRAL-TV

The Piedmont

Piedmont is a French word that means "foot of the mountain." This region encompasses about one-third of the state, rising gently from about 200 feet at the fall line that runs between it and the Coastal Plain to nearly 1,500 feet at the base of the Mountains. Although most of the Piedmont consists of gently rolling terrain, it includes several ranges of rather steep hills, mainly in the Uwharrie Range around Randolph County and the Kings Mountain Range in Cleveland and Gaston Counties. The Piedmont is sometimes referred to as a plateau because it is high and mostly flat. Twenty-seven of the book's gardens are in the Piedmont.

The Coastal Plain

The land and water areas of the Coastal Plain region make up nearly half the area of the state. This region can be roughly divided into two sections: the tide-water area, which is often very flat and swampy, and the interior portion, which

The Wilson Rose Garden is a stunning garden found in the Coastal Region.
JOHN SHELDON

is gently sloping and, for the most part, naturally well-drained because the soils consist of soft sediment, with little or no underlying hard rock near the surface. The average slope ranges from a high of about 200 feet at the line dividing the Coastal Plain and the Piedmont to less than 50 feet near the coast. Six of the book's gardens are located in the Coastal Plain region.

A mountain spring welcomes the blooming of
brilliantly colored azaleas edging a rise of stone
steps at the Biltmore Estate Gardens in Asheville.
THE BILTMORE ESTATE AT ASHEVILLE

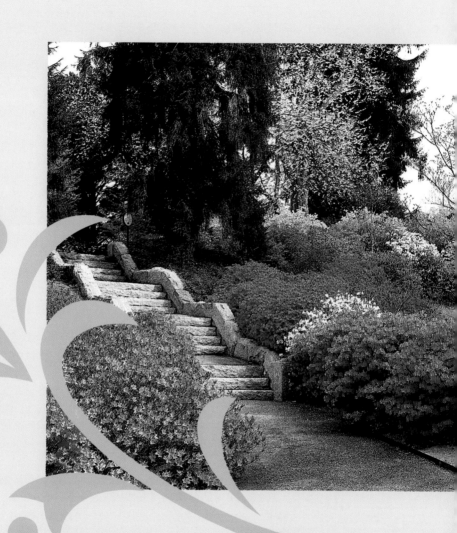

THE MOUNTAINS

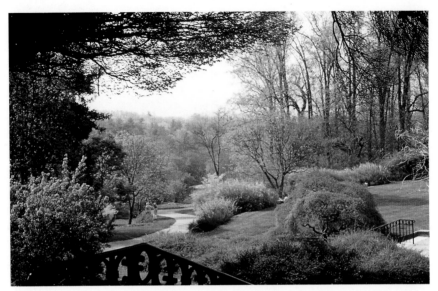

Looking down at the shrub border at the Biltmore Estate. The shrubs are chosen for floral display, leaf color, and texture. THE BILTMORE ESTATE AT ASHEVILLE

The Biltmore Estate at Asheville

Biltmore Village, Asheville, NC 28804
(828) 225-1333 or (800) 543-2961
www.biltmore.com

The Biltmore Estate, a National Historic Landmark, part of the living fabric of Asheville, is a country retreat built for family and friends that is today one of the primary tourist destinations in the country. Originally planned as a working estate, it has about 8,000 acres of gardens, parklands, and managed forests, in addition to the 250-room French chateau built at the end of the nineteenth century, a house that remains the largest private home in the United States.

Frederick Law Olmsted, the great landscape architect, designed the 3-mile-long approach road and the estate's gardens, and many of the original plants and trees are still alive today. The estate features the Walled Garden; the grand Azalea Garden, including one of the country's most complete collections of native and hybrid azaleas; a stunning wisteria arbor; the formal Italian Garden; an amazing array of tulips planted each year to celebrate spring's arrival in the mountains; and a most fragrant collection of thousands of roses.

The estate is located in Asheville's Biltmore Village, at the junction of the Sweeten Creek Road and McDowell Avenue, a block from Biltmore Avenue

(U.S. Route 25). It's about 4 miles north of the Blue Ridge Parkway. Biltmore is open to the public every day except Thanksgiving and Christmas. Hours are January through March from 9:00 A.M. to 4:00 P.M. and from April through December from 8:30 A.M. to 5:00 P.M. Admission is charged to visit both the house and the grounds.

The Botanical Gardens at Asheville

151 W. T. Weaver Blvd., Asheville, NC 28804
(828) 252-5190
www.ashevillebotanicalgardens.org

If you get a bit weary from the noise and bustle in the thriving city of Asheville, remember there's a nearby retreat called the Botanical Gardens at Asheville. The gardens are located next to the Asheville campus of the University of

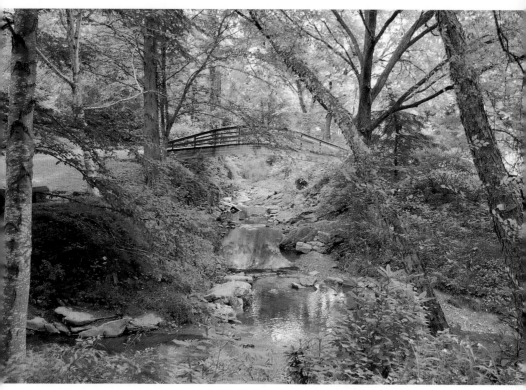

A bridge crossing Ross Creek at the Botanical Gardens at Asheville. The gardens are a place of native trees, running brooks, and a host of native wildflowers.

North Carolina and are maintained by a nonprofit organization that governs the 10-acre preserve. The grounds feature thousands of native plants, shrubs, and trees originally found in the Southern Appalachians, and well-maintained walkways wander through the gardens. The Botany Center is host to a charming gift shop, and the Cole Library contains more than 1,000 books relating to botany, horticulture, ecology, and ornithology.

The gardens began as a civic idea back in November 13, 1960, when an initial meeting took place at Seely's Castle on Town Mountain Road with sixty-one people in attendance. Doan Ogden, a renowned landscape architect and trained naturalist, drew up the plans. The planting of wildflowers began in earnest on March 23, 1964, when more than 5,000 plants were given permanent homes in the garden.

The Visitor Center, housing the gift shop and restrooms, is open mid-March through mid-December from 10:00 A.M. to 4 P.M. daily. The gardens are open every day of the year from dawn to dusk. There is no fee for admission to the gardens, although donations are always welcome. An expanded parking lot allows ample room for cars and tour buses.

Campus Arboretum of Haywood Community College

185 Freedlander Dr., Clyde, NC 28721
(866) 468-6422
www.haywood.edu

Beginning in the 1960s, Western North Carolina's greatest landscape architect, Doan Ogden, originally designed the grounds of this campus arboretum. Unlike most contemporary community colleges, and even some grand universities, Haywood's salute to learning is not just a jumble of bland architecture plunked down on acres of boring lawn. It is, instead, a literal forest, with buildings that seem to be part of the landscape and never intrude on the bucolic scenery. Beginning with the campus entry and its old mill on the edge of a pond, this arboretum immediately shows it is above the ordinary.

The original inventory included 880 trees (more than 22 native species), with most averaging 100 years of age. Since then, many new species of trees, shrubs, and ground covers have been added. The arboretum includes a 1-acre rhododendron garden, which features a leading regional collection of more than seventy-five varieties of rhododendron hybrids and a weeping laburnum

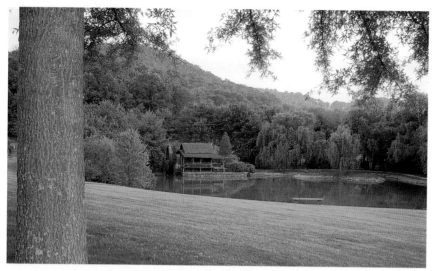

A great sweep of lawn edges the Mill Pond at the entrance to the campus of Haywood Community College, home of the arboretum and rhododendron collection. JOHN PALMER

walkway that blooms in spring; a well-tended herb garden; a rose garden; the Freedlander Dahlia Garden, with more than 400 dahlia varieties; and a woodland area with a number of nature trails, including a 1-mile loop through the center of campus.

The arboretum is located on the campus of Haywood Community College, just a few miles from I-40, and about 20 miles west of Asheville. The exits for the college are clearly marked. There is plenty of parking. The arboretum is open daily without charge.

The Carl Sandburg Home

1928 Little River Rd., Flat Rock, NC 28731
(828) 693-4178
www.nps.gov/carl

The first time I visited Connemara, the home of America's two-time Pulitzer Prize–winning poet and lecturer Carl Sandburg, I was overwhelmed by the house interior. In this house set up on a hill, every room is a reflection of the people who lived there. And wherever you look, you see books, often arranged in orange crates and not in bookcases made of exotic woods. There's even an old Bakelite radio that once brought the news of the world to Flat Rock.

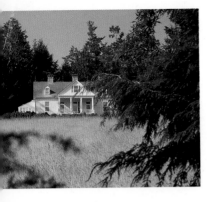

Carl Sandburg's farmhouse looks out on a sea of grass and is surrounded by lovely woods. Unlike other gardens in this book, Connemara was a working farm.

Unlike the other sites described in this book, Connemara was a working farm surrounded by fields and woods, and the entire area is a natural garden. Just outside the house is a small cutting garden, and behind the house is a chair where Sandburg would sit at the end of a busy day and take in the sounds and sights of the local mountains. In the evenings, the Sandburgs and their visitors would walk the winding pathways through the quiet woods.

The Sandburg home is located about 24 miles south of Asheville and 10 miles from Hendersonville. From U.S. Route 25, turn onto the Little River Road, between the post office and the Flat Rock Playhouse. It's .1 mile to the parking lot. The site is easily reached from I-26, turning off at Exit 53 (formerly 22). Look for the directional signs. The park is open daily from 9:00 A.M. to 5:00 P.M. year-round except for December 25 and in cases of inclement weather, when the park may close to visitors until safe to reopen.

Cherokee Medicine Trail

1 Junaluska Dr., Robbinsville, NC 28771
(828) 479-4727
www.cherokeeheritagetrails.org

I've been paying attention to various medicinal plants most of my adult life because they have such fascinating histories, are native plants for the most part, and usually do very well in southern perennial gardens. The plants the Cherokee Indians grew and studied are no exception.

This marvelous new garden features a trail that's only a a quarter mile in length, but if you read the signs, study the plants, and enjoy a quiet walk in the woods, your journey could take hours.

The leaves of the common cucumber tree are more tropical looking than many plants from the Amazon. The scarlet fruit of this magnolia is in the center of the image. T. J. HOLLAND

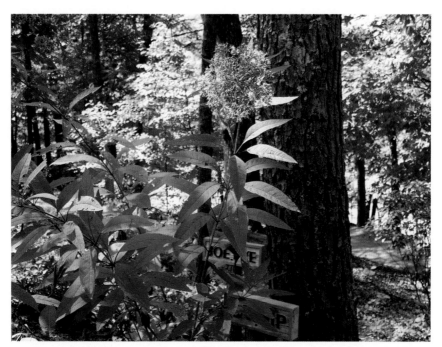

Joe-Pye weed (Eupatorium spp.) is a fall-blooming plant that grows along the trail. A favorite of butterflies, it belongs in every garden devoted to native plants. T. J. HOLLAND

T. J. Holland, manager of the nearby Junaluska Museum, the Junaluska Memorial, and the trail, is quick to point out that the Cherokee people always prided themselves on both being one with nature and having an understanding of just how valuable medicinal plants were to general well-being. Take the common cucumber tree (*Magnolia acuminata*), with its cylindrical, cucumber-like fruit that is initially green and turns a scarlet red and finally dark brown upon maturity. The Cherokees used this tree's bark as a tea for treatment of stomachaches and as a substitute for quinine in the treatment of malaria.

The trail opened in 2002, and each year more plants have been added to the displays. At the beginning of the trail is a symbolic and traditional medicine wheel, which shows the seven basic directions—north, south, east, west, above, below, and within—and represents the powerful effects of spiritual medicine. Along the trail are approximately seventy-five plant varieties, more than half of which were already growing in the area before the trail was constructed.

Robbinsville is slightly below center in Graham County, at the crossroads of Routes 143 and 129. Museum hours are April through October, Monday through Saturday, 7:45 A.M. to 4:30 P.M.; November to March, Monday through Friday, 7:45 A.M. to 4:30 P.M. The Cherokee Medicine Trail and Junaluska Memorial Site are open anytime.

Chimney Rock Park

Route 64/74A Chimney Rock, NC 28720
(800) 277-9611
www.chimneyrockpark.com

At the time of this writing, Chimney Rock Park is up for sale, and it is hoped
that the state will purchase it. In the meantime, the park will remain open.

Passing Bat Cave and the once famous Esmeralda Inn, on your way down to
Lake Lure (in whose waters the submarine sequence for *The Hunt for Red Octo-
ber* was filmed), on your right you go by the entrance and bridge to Chimney
Rock Park. After carefully driving up a serpentine mountain road, you reach a
plateau above beautiful Hickory Nut Gorge at an elevation of 2,280 feet. At the
far end of the parking lot, you look up at a towering 315-foot monolithic rock
topped with a fluttering American flag that's often silhouetted against a real Car-

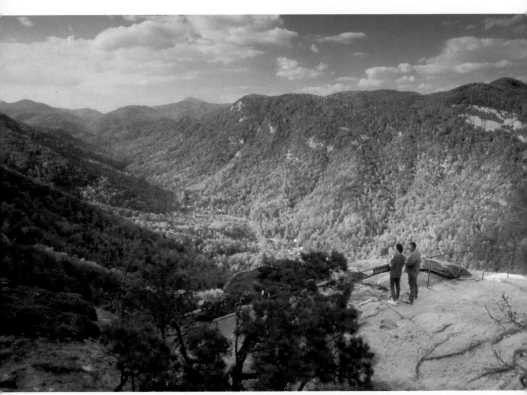

*A stunning fall view of Hickory Nut Gorge as seen from Exclamation Point at Chim-
ney Rock Park. This lookout is just one of many stops along the Skyline Trail to the
404-foot Hickory Nut Falls.* CHIMNEY ROCK PARK

olina blue sky. From here you take an elevator ride up a once-dynamited shaft, until the doors open and you climb stairs to the top of the rock, where you have a spectacular 75-mile view. On a clear day, you can see Charlotte.

Now the walk begins: You climb many more flights of stairs and soon find a wandering trail along the top of the ridge with the valley on your right and cliffs on your left, passing a natural garden of wildflowers that looks as though a master gardener tended it just a few hours before your arrival.

At an elevation of 2,480 feet, you will walk to Exclamation Point, the pinnacle of the park, exceeding Chimney Rock's elevation by 200 feet. You can see the pass between the mountains on your left and shimmering Lake Lure on your right.

The park covers an area of nearly 1,000 acres and features Hickory Nut Falls, one of the highest waterfalls east of the Mississippi, with a drop of more than 400 feet.

It also has a number of hiking trails, and because of the area's mix of topography and climate, including the minerals in the rocks, the soils, the availability of moisture, and the amount of sunlight, more than 550 species of vascular plants—including 32 ferns and fern allies—have been identified. There's even a rare selaginella that botanists denied could exist in the park until they drove from the State University in Raleigh to see it.

Chimney Rock Park is located 25 miles southeast of Asheville and is open every day, weather permitting, except Thanksgiving, Christmas, and New Year's Day. Hours for obtaining tickets are 8:30 A.M. to 4:30 P.M.; the park remains open for another hour and a half. From Asheville, take U.S. Route 74A east for 25 miles. The entrance to Chimney Rock Park is just 1 mile east of the inn, and Lake Lure Beach is about 2 miles farther east on Route 64/74A.

Craggy Gardens

Adjacent to milepost 364 on the Blue Ridge Parkway (Visitor Center)
www.blueridgeparkway.org/craggy_gardens.htm

Many areas of Western North Carolina are best described as natural gardens, places where the hand of man has never held sway, but because of the climate, the mountains, the rocks, and the beautiful vegetation, they appear to be under design standards usually found in great estate gardens. The area local Ashevillians have long called Craggy Gardens is one of these places.

In late spring the mountain ash (*Sorbus Americana*) trees bloom with umbels of white blossoms, followed in mid-June by brilliance of the Catawba

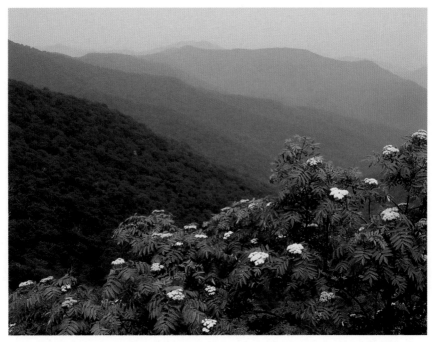

In late spring the mountain ash trees bloom with umbels of white flowers that by autumn form bunches of brilliant red berries. Craggy Gardens is a natural garden where the hand of man has never held sway.

rhododendrons, and all through the summer months the wildflowers continue to bloom. Then in early fall the brilliant red berries of the ashes appear, outshining the cardinals as they fly from branch to branch.

The Craggy Gardens Trail, left of the Visitor Center, is an easy walk though luxurious ferns, trees bedecked with lichens, and mosses continually fresh from the above-average rains. About half a mile, you reach open fields dotted with bushy islands and wildflowers. In case it rains on your picnic, you'll find a marvelous open barn built in the 1930s. Across from the Visitor Center, you can look out for miles and in the distance see part of the Asheville Reservoir, a long, slender lake sparkling under a Carolina blue sky.

Craggy Gardens is host to many rare and endangered plants, whose roots are easily damaged by hikers. Some areas are protected. Be sure to remain on the trails. At more than 5,000 feet in elevation, temperatures are much cooler here than in the city below, sometimes more than a 10-degree difference, so carry along a light jacket.

Craggy Gardens can be found adjacent to milepost 364 on the Blue Ridge Parkway, about 24 miles north of Asheville. The Blue Ridge Parkway is usually open but can be closed as a result of ice, snow, or inclement weather.

Daniel Boone Native Gardens

Daniel Boone Park, Boone, NC 28607
(828) 264-6390
www.boonechamber.com/guide/guide

Visiting the Daniel Boone Native Gardens, with its collection of native plants, rhododendron thickets, and historic Squire Boone Cabin, is close to visiting the same area 250 years before, as long as one ignores any jet trails above. The gardens were given to the community by Daniel Boone VI, a direct descendant of the famed American frontiersman, and officially opened to the public in 1996.

The gardens feature an impressive display of native flora of the Appalachian region, with the collection arranged in a 3-acre informal landscape design adjacent to Horn in the West, an outdoor drama depicting Daniel Boone and the mountain men in their struggles toward independence and frontier settlement. The rhododendron thicket, sunken garden, wishing well, reflection pool, and meditation garden have restful inclinations and charm. The native wildflowers are dazzling in the spring, but don't forget, there are fall wildflowers too. Especially beautiful are the Roan Mountain goldenrod (*Solidago roanensis*), named for the area where it was first discovered, and the fall aster (*Aster curtisii*), a 5-foot bloomer with violet-blue flowers that contrast with the brilliant fall colors of autumn.

The historic Squire Boone Cabin stands at the Daniel Boone Native Gardens. The gardens were a gift to the community from Daniel Boone VI.
FRANK YOUNG, DANIEL BOONE NATIVE GARDENS

A patch of goat-beard (Aruncus dioicus) *blooms by the cabin door with upright panicles of hundreds of small, but fragrant, white flowers.* FRANK YOUNG, DANIEL BOONE NATIVE GARDENS

The gardens are located in the Daniel Boone Park, off Horn in the West Drive. From U.S. Route 421, travel 1 mile on the NC Route 105 Extension, then turn right onto Horn in the West Drive. Weather permitting, the gardens are open daily from May 1 to October 15 and on weekends in October from 9:00 A.M. to 6:00 P.M. From June 15 to August 15 they remain open until 8:00 P.M. There is a small admission charge.

Grandfather Mountain

U.S. Route 221 at Blue Ridge Parkway, Linville, NC 28646
(800) 468-7325
www.grandfather.com

The late Hugh Morton was a rare person, a property owner with tremendous respect for his land and his mountain called Grandfather. This is the highest peak in the Blue Ridge mountain range and an internationally recognized nature preserve. From here you can look out at the world with 360-degree views that fire the imagination, even when low-flying clouds distort your vision or gray fog shrouds the landscape in mystery.

In spring the 3,000- to 4,000-foot mountains lose their brown netting of leafless trees to green up with colors so fresh you will forget the year before. The spring flowers are followed by rhododendrons and then the wildflowers of summer, which give way to the vibrant reds, gold, and yellows of fall.

Even plant lovers can marvel at the Mile High Swinging Bridge that Morton constructed to give visitors easy access to the wondrous views. This 228-foot suspension bridge spans an 80-foot chasm over a mile high in elevation. In addition, you'll find eleven trails of varying difficulty, ranging from an easy walk in the woods to a trek across rocky peaks.

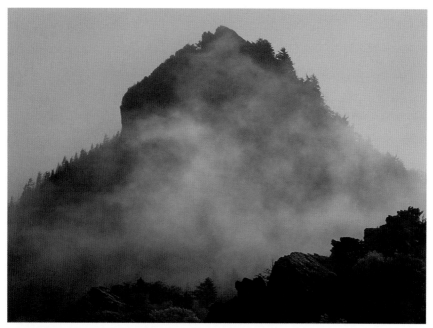

Grandfather Mountain looms up through a rising curtain of fog. The climate up Linville way can be quirky to say the least. HUGH MORTON

The mountain is open to visitors daily from 8:00 A.M. to 5:00 P.M. There is an admission fee. The entrance to Grandfather Mountain is located on U.S. Route 221, 2 miles north of Linville and 1 mile south of milepost 305 on the Blue Ridge Parkway. Because the mountain is also open to U.S. 221, if the parkway is closed because of inclement weather, the park may still be open, weather permitting, during the winter months.

Highlands Biological Station
265 N. Sixth St., Highlands, NC 28741
(828) 526-2602
www.wcu.edu/hbs

From Asheville to Highlands is an easy fly for a crow, but the trip is a bit longer by car. The Highlands Biological Station is located near a crest of the Blue Ridge Mountains on a 4,000-foot-high plateau in a town advertised as the "highest incorporated town east of the Rocky Mountains." This is a year-round biological field station with a mission to promote research and further education in

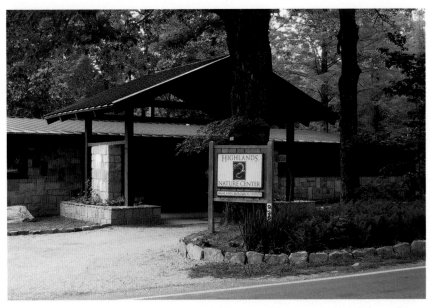

The Highlands Biological Station in Highlands is a working institution dedicated to the wide diversity of both flora and fauna found in North Carolina. ROBERT A. TUCKER

ecology, evolution, and conservation, focusing on the amazing diversity of the flora and fauna of Western North Carolina.

This institution serves as a refuge and demonstration garden for more than 500 species of plants that flourish in our natural forests, bogs, and swamps, plus wetland communities. Well-marked trails display gardens of native azaleas, carnivorous plants, butterfly-pollinated plants, and edible and medicinal herbs. Many of the native plants are recommended for use in both residential and commercial developments. You will also find natural areas such as the old-growth hemlock hardwood forest through which the Coker Rhododendron Trail wanders. The garden covers about 11 acres on the shores of the 4-acre Lindenwood Lake.

I've walked the garden in spring, summer, and fall, always finding plants and flowers of interest. When I checked the blooming schedule for August 7, 2006, I found more than fifty species of wildflowers in bloom, including meadow beauty (*Rhexia virginica*), oakleaf hydrangea (*Hydrangea quercifolia*), and yellow passionflower (*Passiflora lutea*).

The Highlands Botanical Garden is free and open to the public year-round from sunrise to sunset. Highlands is easily reached from Asheville and Hendersonville by taking I-26 east, turning off on U.S. Route 64 west, and driving to Cashiers and Highlands.

Joyce Kilmer Memorial Forest

Cheoah Ranger District USFS, Rt. 1, Box 16-A, Robbinsville NC 28771
(828) 479-6431
www.joycekilmerslickrock.com

The Joyce Kilmer Memorial Forest is linked to the Slickrock Wilderness, and this combination is responsible for one of the most emotionally riveting and inspirational natural gardens in the United States.

The area was a forest primeval until the early 1900s. Originally part of the Cherokee Indian Nation, the forests were explored in the 1750s by Lt. Henry Timberlake and then in 1835 were ceded to the United States. In the mid-1800s they were settled by a few families who began clearing for homesteads. In 1915 the Babcock Lumber Company purchased the Slickrock area and began logging operations. Fortunately for the world at large, in 1922 the company had to halt operations because of dam construction on the Little Tennessee River. About one-third of the forest had escaped logging.

The Forest Service purchased the land in 1936, and the Little Santeetlah Creek Watershed was dedicated to Mr. Kilmer, who died in the First World

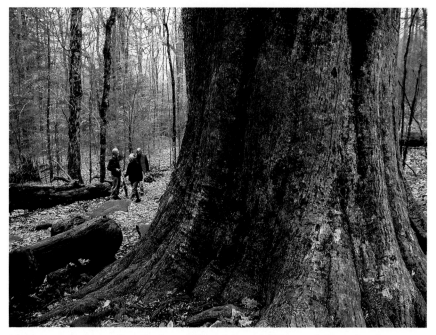

The trees rule the earth at the Joyce Kilmer Memorial Forest, dedicated to the poet who wrote "Trees." The forest covers 3,800 acres. JERRY BIRDWELL

War and is best known as the poet who wrote "Trees." Today it is one of the largest tracts of virgin forest east of the Mississippi River.

Rather than being just isolated trees, this forest covering 3,800 acres is one gigantic organism, linked together with intertwining roots of trees, shrubs, ferns, wildflowers, and mossy logs. Some trees stand over 100 feet tall and are more than 20 feet in circumference. The 2-mile trail is soft underfoot, covered with leaves dropped from the overhead branches.

The forest is located about 15 miles from Robbinsville. Take U.S. Route 129 north to a well-marked forest service road into Joyce Kilmer Forest. Hours are from dawn to dusk. From April through October, a forest ranger is there to answer questions.

Montreat Conference Center

Assembly Dr., Montreat, NC 28757
(828) 669-2911
www.montreat.org

Take a very scenic 15-mile drive east of Asheville—via I-40—and visit the Montreat Conference Center for a trip back in time. As you pass through the stone gate and enter this spiritual retreat, you'll be traveling on Assembly Drive

The Montreat Conference Center sits amid a forest cove of 4,000 acres just outside the town of Black Mountain. Lake Susan is a crowning jewel.

One of the joys of a summer afternoon is casting a line into the waters of Flat Creek, just below the dam and the lake.

as it winds its way under majestic hemlocks, a road lined with elegant and historic vacation homes (some now full-time residences), all nestled in a 4,000-acre cove of the Blue Ridge Mountains.

Montreat is one of three national conference centers of the Presbyterian Church (USA), and it welcomes 35,000 visitors annually for rest, recreation, and spiritual renewal. The conference center's historic Assembly Inn, the stately Winsborough, the charming Glen Rock Inn, and quaint guest lodges scattered throughout the community provide a variety of lodging options for visitors.

Montreat Conference Center, along with the town and Montreat College, is committed to preserving and protecting the beauty that surrounds it. Hikers and nature lovers enjoy miles of scenic trails that weave their way through almost 2,500 acres of rhododendron and azalea thickets dotted with wildflowers all permanently protected under a conservation easement agreement with state and local environmental agencies. In addition, the entire Montreat community, including the conference center, Montreat College, and Montreat residences, is a Community Wildlife Habitat, certified by the National Wildlife Federation. Montreat is the first community in North Carolina to receive this distinction.

Near the conference center, you'll find a variety of features, ranging from the waters of Lake Susan to the exposed rock found on Lookout Mountain, the wooded trails past the old Montreat reservoir, and the majestic heights of Graybeard Mountain at 5,240 feet.

To visit the conference center, take the Black Mountain/Montreat/Route 9 Exit 64 from I-40; turn north on Route 9 and go through three traffic lights in Black Mountain. Route 9 will become Montreat Road, and you will drive about 2 miles to the Montreat entrance. From the gate, continue approximately 1.5 miles to Lake Susan and Assembly Inn at the heart of the conference center.

The North Carolina Arboretum

100 Frederick Law Olmstead Way, Asheville, NC 28806
(828) 665-2492
www.ncarboretum.org

The North Carolina Arboretum is a 434-acre public garden located within the Bent Creek Experimental Forest of the Pisgah National Forest not far from Asheville. The property is surrounded by the botanically diverse Southern

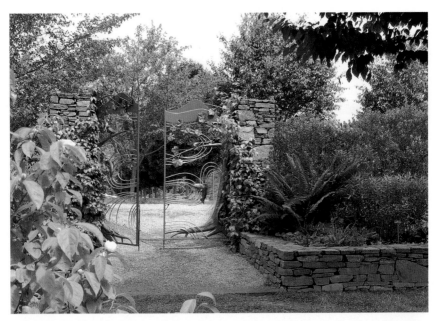

Steel gates by Joseph Miller and David Brewin welcome visitors to the formal gardens at the North Carolina Arboretum, just off the Blue Ridge Parkway.

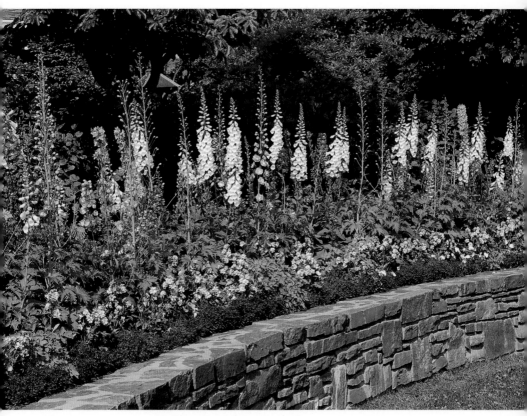

Floral designs at the entrance to the Aboretum change with the seasons. Here lark-spurs make a stunning display to welcome the summer.

Appalachian Mountains and offers one of the most desirable natural settings of any public garden in America. Development of the property began in 1990.

I've walked the arboretum all seasons of the year, and its gardens are always a diverse and welcome sight on most any day, rain or shine. The Plants of Promise Garden is always in tip-top shape and features new and time-tested perennials that grow well here in the mountains. In the stunning Quilt Garden, plants are changed according to the seasons. Look for the new Bonsai Exhibition Garden, an entire area devoted to a Japanese-style pavilion and landscaped by Mike Oshita, a Japanese gardener trained in the classic traditions and knowledgeable about melding the traditions of the East and West.

There are many trails for comfortable walking. Some are restricted to hiking and foot traffic only, while others can be used for both hiking and cycling.

The arboretum is located just down from mile marker 393 on the Blue Ridge Parkway or is easily reached from Exit 33 (old Exit 2) of I-26, about 9 miles

from downtown Asheville. Hours are Monday through Saturday from 9:00 A.M. to 5:00 P.M. and Sundays from noon to 5:00 P.M. Greenhouse hours are Monday through Friday from 8:00 A.M. to 2:00 P.M. Property hours are April through October, 8:00 A.M. to 9:00 P.M. and November through March from 8:00 A.M. to 7:00 P.M. Both property and buildings are closed on December 25. A parking fee of $6 per car is charged every day but Tuesday.

Pearson's Falls

2720 Pearson Falls Rd., Saluda, NC 28806
(828) 749-3031
www.pearsonsfalls.com

Back in the 1930s the Tyron Garden Club rescued Pearson's Falls from a timber company, and today it's a botanical star hidden in the Blue Ridge Mountains. The garden's 250 acres are crossed by two rushing streams and focus on the namesake waterfalls. The falls were named for a young railway engineer, Charles William Pearson, who discovered them while scouting a route for the great Southern Railroad.

The trail is an easy walk through ferns and wildflowers with well over 200 species of native ferns, flowering plants, and even algae and mosses. As a result, the area serves as a living laboratory for many university botany departments. Look behind the falling waters to see the amazing variety of mosses and algae that live on the rock, continually moistened by the watery sprays.

The Gatekeeper's House was added when the gardens finally needed full-time supervision, with more than 30,000 people visiting each year. Donald Culross Peattie wrote a book about Pearson's Falls that lists most of the plants found in this glen; it is available for sale at the site.

Pearson's Falls has a summer and winter schedule. The summer schedule runs from March 1 to October 31, with the gardens open Tuesday through Saturday, from10:00 A.M. to 6:00 P.M. and Sunday from noon to 6:00 P.M., and closed Monday except when Memorial Day, Fourth of July, or Labor Day falls on a Monday. Gates close at 5:15 P.M.. The winter schedule runs from November 1 to February 28, with the gardens open Wednesday through Saturday from 10:00 A.M. to 5:00 P.M. and Sunday from noon to 5:00 P.M., and closed Monday and Tuesday. Gates close at 4:15 P.M.

Picnicking is permitted at several picnic sites. A two-table shelter is available if needed.

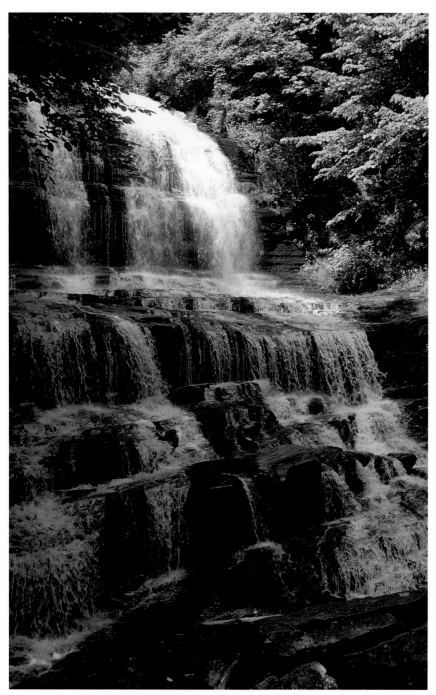

The falling waters at Pearson's Falls are beautiful year-round and provide a cooling climate for an amazing variety of mosses and algae that live on the rock.

Richmond Hill Inn Gardens

87 Richmond Hill Dr., Asheville, NC 28806
(800) 545-9238
www.richmondhillinn.com/gardens.shtml

Richmond Hill sits about five minutes from downtown Asheville, on top of a rise that offers beautiful views of the surrounding mountains and, except for an occasional train whistle or auto sound, not an inkling that it's the twenty-first century. Finished in 1889, this grand Victorian residence became the private residence of Ambassador and Congressman Richmond Pearson and was designed by James G. Hill, the supervising architect for the U.S. Treasury buildings of the nineteenth century. The inn has a revered place on the National Register of Historic Places.

The well-cared-for Victorian landscape features manicured gardens and natural areas, monuments, and several water features. Completed in 1996, the formal Parterre Garden sits in front of the Garden Pavilion and was modeled after the great parterres of the Victorian age. It features tree roses, and native and tropical perennials filling geometrically landscaped garden areas sur-

The formal gardens at Richmond Hill were inspired by the English gardens so popular during the Victorian Era. They feature a colorful mix of annuals, perennials, and roses.

rounded by boxwood hedges, with crushed gravel pathways between the beds. The meandering stream and waterfalls are planted with a number of bog and stream species.

One of the more unusual sights in the garden is the use of the exotic princess tree (*Paulownia tomentosa*) from Japan as a small landscape tree with gigantic leaves, because it's pollarded and cut down to the ground in early spring.

Coming up the road to the main house, you approach the porte cochere, a covered entrance that today protects visitors from summer storms but in ages past was open to horse-drawn buggies. Just to the left of the overhang is the Sidney Lanier Monument and Garden, dedicated to the noted poet and musician, who camped on Richmond Hill back in 1881.

Richmond Hill is just 3 miles from downtown Asheville, near Exit 25 of U.S. Route 19/23 (the future I-26). Summer hours run from April through October, with the hotel open from 9:00 A.M. to 7:00 P.M. Winter hours run from November through March, from 9:00 A.M. to 5:00 P.M.

Roan High Bluff Natural Gardens
Road from Carver's Gap
www.ncnatural.com/NCUSFS/Pisgah/roan-mtnj.html

Hundreds of acres of Catawba rhododendrons (*Rhododendron catawbiense*) cover the high elevations of the 5-mile-long ridge known as Roan Mountain, usually blooming in the third week of June. The height ranges from 6,286 feet at Roan High Knob to a low of 5,500 feet at Carver's Gap. A myth about the name is that it refers to the color of Daniel Boone's horse, as the pioneer was a frequent visitor. The mountain straddles the state line between Tennessee and North Carolina.

This is a startlingly beautiful area of the state and whatever the time of year or the kind of weather you might experience, walking the pathways of this ridge is a once-in-a-lifetime experience. And remember, the Appalachian Trail is not far away.

The grassy balds in this area are both rare and quite beautiful ecosystems, their origin still not clearly understood. The plants around the balds include Fraser firs, rhododendrons, Roan Mountain goldenrod, and the lovely Gray's lily, plus many others.

In the late 1950s a tiny insect called the balsam woolly adelgid first appeared in the Southern Appalachians, where it feeds on mature Fraser firs. But young

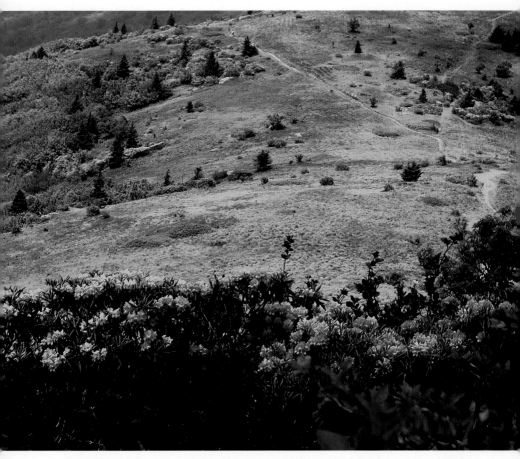

Regardless of the season, native plants grow in the Natural Gardens on Roan High Bluff, either blanketed in winter snow or, as above, ringed with blooming rhododendrons that open to the sun every June. JERRY BIRDWELL

seedlings are not affected, so they form carpets of tiny firs along with the mosses, ferns, and wildflowers.

At one point after parking your car, you can easily walk a little over a mile—through shaded woods with fir seedlings and lovely mosses—to the Roan High Bluff Overlook. There you'll find a large wooden platform where you can hang over the valley below and watch the ravens of Roan Mountain circle above, diving on wind currents and obviously flying for the pure joy of it. It's often rainy and cool around Roan Mountain, so carry along a sweater or raingear, even in summer.

To drive to Roan Mountain, take NC Route 261 north from Bakersville, North Carolina, or follow TN Route 143 south from Roan Mountain, Ten-

nessee. The highway crosses Roan Mountain at Carver's Gap. The 2-mile road from Carver's Gap to the gardens is open from April through November. After the road is closed, skiers and hikers can still explore the winter beauty of the area. An information cabin is staffed and open from 10:00 A.M. to 5:00 P.M. every day from Memorial Day through Labor Day and five days a week during April, September, and October.

Wilkes Community College Gardens

1328 South Collegiate Dr., Wilkesboro, NC 28697
(336) 838-6100
www.merlefest.org/Gardens.htm

In 1987, world-renowned musician Arthel "Doc" Watson founded the Merle Watson Garden for the Senses in honor of his son and performing partner, Merle, who died in a tragic accident. To raise funds for the garden, the college sponsors an annual benefit concert known as Merlefest, with music performed by the biggest names in bluegrass and folk music.

Theme gardens are found throughout the campus, including the Japanese Garden, Conifer Garden, Garden of Native Plants (including a 1-mile walking

The gardens of Wilkes Community College are famous for a number of themes and include the Japanese Garden, the Conifer Garden, and a fine collection of plants native to the area. WILKES COMMUNITY COLLEGE

trail), Rose Garden with more than 600 rose bushes, and Stanley 4-H Vegetable Garden. There are also a wildflower meadow and, in a salute to the history of Wilkes County, an old log cabin.

The Garden for the Senses is close to completion and contains plants that both emphasize fragrance and have unusual and identifying textures. The garden's basic design was prepared to be helpful for the visually impaired and features gently sloping walkways while the plants all have identification labels in Braille.

Noted Goldsboro sculptor Patricia Turlington designed and sculpted a 150-foot-long serpentine brick wall that consists of a series of elaborate brick sculptures called *Nature's Alphabet* and the *Tree of Memories*. The first panel is 16 inches high and 27 feet long; it begins with an armadillo representing A and ends with a zebra for Z. The other panel is 8 feet tall and 15 feet wide and was constructed using four colors of clay: two shades of yellow for the leaves and white and brown to represent textured bark. The tree is carved into brown brick, and the panel is shaped like the Blue Ridge Mountain foothills that surround Wilkesboro.

To reach the college, from the intersection of U.S. Route 421 and NC Route 268, travel west on NC 268 for half a mile to the campus. The gardens are open year-round.

The Greenhouse Rose Garden of Reynolda Gardens was restored using roses listed on the 1917 landscape plan. The refurbished 1912 Lord and Burnham greenhouse contains collections of tropical and succulent plants.
PHOTO ©WFU/KEN BENNETT

THE PIEDMONT

Bethabara Gardens

Historic Bethabara Park
2147 Bethabara Rd., Winston-Salem, NC 27106
(336) 924-8191
www.bethabarapark.com/gardens.htm

When it comes to uncovering the past, nothing tells a better story than the unearthing of the long-lost colonial garden complex near Winston-Salem. The story begins in 1753 with 100,000 acres of land called the Wachovia Tract, which belonged to a small Moravian community called Bethabara (Hebrew for "house of passage").

The year 1754 saw the first planting of the garden for the settlement, with Bethabara serving as a temporary administrative center until 1772, when the congregation town of Salem was built. Tradesmen were then moved to Salem, and Bethabara became a sleepy agricultural town whose farms swallowed the gardens. In 1988, when archaeologists were asked to find the site, the fences and walls had long since disappeared.

But according to Ellen Kutcher, the present director, they pushed ahead with explorations, using old garden maps drawn by North Carolina's first forest ranger, Christian Reuter, and found the original site. "It turned out to be an exciting dig," says Kutcher, "because there, still buried under the soil, they found the original fence posts."

Since the Moravians were not indentured servants, but worked for the good

of the community, a relatively few members could raise food for the many. Thus the community was able to support a thriving group of more than thirty different tradesmen, including professionals like doctors and ministers. Eventually this horticultural endeavor attracted non-Moravians to settle around the borders of the nearly 100,000-acre Wachovia Tract, and traders came from 60 miles away.

The reconstructed community gardens are part of a historic park that includes a Visitor Center, historic buildings, nature trails, and a 180-acre wildlife preserve with walking trails.

The reconstructed gardens of Bethabara feature nature trails, historic buildings, marvelous salutes to vegetables and annual flowers, and a wildlife preserve. A. DANIEL JOHNSON

Take the I-40 Bypass, turning left on U.S. Route 52 north. Turn left on University Parkway, then right on Bethabara Park Road. The park is open April 1 through November 30, but closed on Thanksgiving Day. Hours are Tuesday through Friday from 10:30 A.M. to 4:30 P.M. and Saturday and Sunday from 1:30 P.M. to 4:30 P.M..

Blue Jay Point

3200 Pleasant Union Church Rd., Raleigh, NC 27614
(919) 870-4330
www.wakegov.com/locations/bluejaypoint.htm

Blue Jay Point County Park consists of 236 acres on the shores of Falls Lake in northern Wake County. The park's mission is to offer environmental education programming in a natural setting.

The land, located next to the Blue Jay Center for Environmental Education, gives visitors a chance to view presentations to be used as ideas for their own backyard wildlife habitat and native plantings. The gardens and pond are also important staging areas for many outdoor activities.

The Blue Jay Center features an exhibit exploring many environmental and natural-resource themes, with water as the chief interest. The first set of

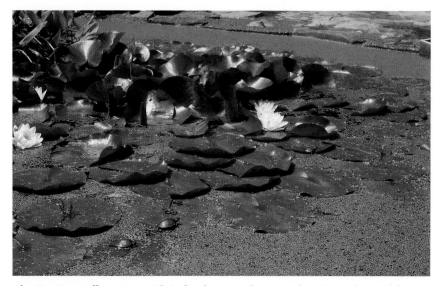

Blue Jay Point offers visitors ideas for their own home gardens. Here the pond features water lilies in bloom surrounded by the tiny leaves of duckweed, the smallest blooming plant in nature. BLUE JAY POINT

exhibits offers glimpses of the water cycle, the Neuse River basin, the Falls Lake watershed, and Raleigh's reliance on Falls Lake for its drinking water. The next exhibit gives visitors a look at many current environmental perils, as well as some actions they can take to help preserve water quality. The Nature Discovery Room gives a close-up look at natural habitats found at Blue Jay Point, including plant exploration, resident animals, and the area's ecology.

There are 4 miles of trails within the park. Hikers will find that Blue Jay's Section VI of the Falls Lake Trail connects with North Carolina's Falls Lake Trail, thus extending the hiking opportunities well beyond the boundaries of Blue Jay Point. Dogs are permitted but must remain on a 6-foot leash.

For all who also enjoy the art of fishing, the shores of Blue Jay Point provide informal bank fishing in Falls Lake, but all North Carolina inland freshwater fishing regulations apply. If you live in Wake County, you may fish without a permit between 8:00 A.M. and sunset, seven days a week, if you use naturally digestible bait, such as worms or hot dogs.

From the I-440 Beltline encircling Raleigh, take Six Forks Road north. Turn right on Pleasant Union Church Road. This will lead you to the entrance of Blue Jay Point County Park. The park is closed on Thanksgiving, Christmas Eve and Christmas Day, and New Year's Day.

The Calvin Jones House and the Ruth Snyder Garden

414 N. Main St., Wake Forest, NC 27588
(919) 556-2911

Pam Beck introduced me to the Calvin Jones House and the Ruth Snyder Garden in mid-September 2006. The day was warm, breezy, and sunny, perfect for walking the sidewalk along North Main Street and watching a neighborhood in transition.

Situated in the heart of Wake Forest on 4 acres located along this road, also known as U.S. Route 1A, are the historic Calvin Jones House and the beautiful Ruth Snyder Garden. Dr. Calvin Jones built the house in 1820, and in 1830 he sold the house and farm to Dr. Samuel Wait, the man who founded the institution that became Wake Forest College. The town grew around the college, and what is now North Main Street or U.S. 1A became Faculty Row. In 1956, on the saddest day in town history the college moved to Winston-Salem, leaving the town nearly vacant. But today the Southeastern Baptist

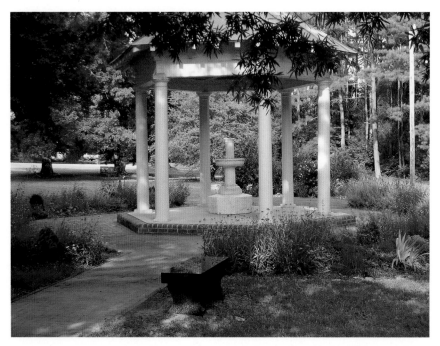

The pavilion at the Ruth Snyder Garden is shelter to the fountain and the well that once pumped water for the original garden campus for Wake Forest College.

Theological Seminary occupies the campus, and the town is once again full of students and teachers.

Originally located at the center of the campus, the Calvin Jones House was moved to its present location, as modern buildings were required for the campus. Many artifacts from the college campus have been moved to the museum site, including the Old Well, the Sundial, and the old Arch, inscribed with the names of students from the Class of 1909. Large, open lawns on the property invite the locals to picnic, fly kites, attend concerts, or simply stroll with their children on the grounds. Magnolia trees remind visitors, especially the alumni, of the magnificent magnolias that used to grow on the college campus.

According to Hugh Nourse, the present garden curator, the garden was built around three major trees: an elm, a willow oak, and a Carolina ash. "Native and traditional southern shrubs, such as winterberry, fothergillas, Virginia sweet-spire, sweet Betty, rhododendrons, and 'George Tabor' azaleas, form an enclosure that shields the visitor from the noises of the road. And don't overlook the extensive edges of hosta, with ground covers such as the variegated yellow archangel and the perfume geranium, which in summertime gently scents the air with the fragrance from its leaves."

The Calvin Jones House is open for tours on Sunday from 2:30 to 4:30 P.M. and Tuesday through Friday from 10:00 A.M. to 4:00 P.M., as well as other times by appointment. The garden is always open. Parking is available on Walnut Street. The site is owned and operated by the Wake Forest College Birthplace Society.

Cape Fear Botanical Garden

536 N. Eastern Blvd., Fayetteville, NC 28301
(910) 486-0221
www.capefearbg.org

Cape Fear Botanical Garden was established in 1989, just two years before the dreadful remake of the thriller that originally starred Gregory Peck and saluted boating on the Cape Fear River. The mission of this garden concerns the entire community of plant lovers in southeastern North Carolina.

The 85-acre site is at the confluence of the Cape Fear River and Cross Creek, an area that abounds in the flora and fauna of the Cape Fear river basin. It is an urban forest replete with nature trails, a natural amphitheater, steep ravines that support a number of unusual plants, an open pine forest, and hardwood slopes that lead to the lush riverbank. Ponds, pools, and waterways attract water-loving birds and beasts and host a variety of aquatic plants. Drawn by such a magnet, the bird life alone can stir a gardener's heart. Because of the natural setting in the Piedmont climate, this garden can entertain the eye and rest the spirit all year long.

Dedicated garden purists will find a gazebo and the Great Lawn, all bordered by perennial flowerbeds, in addition to many specialty gardens providing insights for designing or redesigning their own gardens back home.

Hours are March until mid-December, Monday through Saturday from 10:00 A.M. to 5:00 P.M. and Sunday from noon to 5:00 P.M.; and mid-December through February, Monday through Saturday from 10:00 A.M. until 5:00 P.M. and closed Sunday.

From I-95, take Exit 52 (NC Route 24 west) and go approximately 5 miles. Turn right onto Route 301N (Eastern Boulevard) and proceed ⅛ mile. The gardens will be on your right.

The Cape Fear Botanical Garden salutes the flora and fauna found along the Cape Fear River and includes ponds, pools, and waterways, not to mention a host of water-loving birds and beasts. HODGES ASSOCIATES, INC.

Coker Arboretum

Cameron Ave. and Raleigh St., Chapel Hill, NC 27599
(919) 962-0522
www.chapelhillmuseum.org/About/Archives/PastExhibits/trees

The Coker Arboretum is at the center of the justly famous University of North Carolina. The tracts of trees and gardens are managed by the North Carolina Botanical Garden, and these 5 acres are one of the garden's oldest tracts. The land is home to an extensive collection of ornamental plants and shrubs.

In 1903 Dr. William Chambers Coker, the university's first professor of botany and the first chair of the University Buildings and Grounds Committee, turned his efforts to developing a 5-acre boggy pasture into an outdoor classroom, chiefly for the study of native North Carolina trees, shrubs, and vines. Thanks to the land bridge that once connected today's North America to Asia, our native plants are often closely related to similar species found in Japan and China. Beginning in the 1920s and continuing through the 1940s, Dr. Coker added many East Asian trees and shrubs, enhancing the beauty and educational value of the arboretum. Look for the North Carolina State Cham-

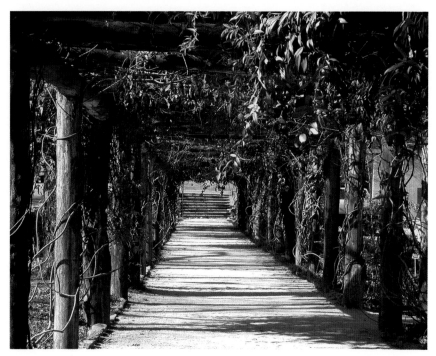

A rustic arbor at the Coker Arboretum is home to a native rambler called the cross-vine (Bignonia capreolata). COKER ARBORETUM

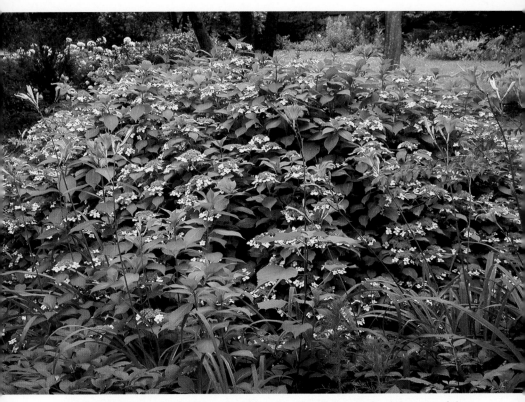

A mass of blooming hydrangeas sparkle at the edge of the woods while some of the original daylilies open for their day in the sun. COKER ARBORETUM

pion Walter's pine (*Pinus glabra*), first identified in 1788 by southern botanist Thomas Walter.

Today the collection consists of a wide variety of plantings, including flowering trees and shrubs as well as spring bulbs, spring ephemerals, and perennial displays. Shiny red hurricane lilies (*Lycoris radiata*) planted before World War II return faithfully every year. No matter what the season, the arboretum is there to be enjoyed.

A one-hour tour departs from the stone gathering circle along Cameron Avenue at 11:00 A.M. on the third Saturday of each month. Limited parking is available on a first-come, first-served basis. Call the arboretum for details.

From I-40 west, coming from Raleigh, Durham, or other points east, take Exit 273b and merge onto Route 54. After 2 miles, Route 54 becomes Raleigh Road. After another mile, turn right onto Country Club Road. The arboretum is located at the corner of Country Club Road and Raleigh Street. It is open from dawn to dusk daily, year-round.

Daniel Stowe Botanical Garden

6500 S. New Hope Rd., Belmont, NC 28012
(704) 825-4490
www.dsbg.org

Fourteen miles north of Charlotte, Daniel Stowe Botanical Garden is a study in having a dream and following it through to a great end. Today the site encompasses more than 110 acres of beautifully designed gardens, glistening fountains, woodland trails, and plant displays par excellence.

In 1989 Mr. Stowe, a retired textile executive from Belmont, set aside 450 acres of rolling meadows, dense woodlands, and lakefront properties for the establishment of a world-class botanical garden. In October 1999, 110 acres were opened to the public, part of a forty-year master plan.

The continued use of tropical plants in imaginative ways makes this garden quite different from the rest. The Charlotte area can be very hot in the summer and early fall, but when some other public gardens are overwatering and over-fertilizing their annuals and hoping the perennials will last another few weeks, this garden is just hitting its stride. Using the great and often garish colors of tropical blossoms and the rich textures of tropical foliage in eye-popping ways,

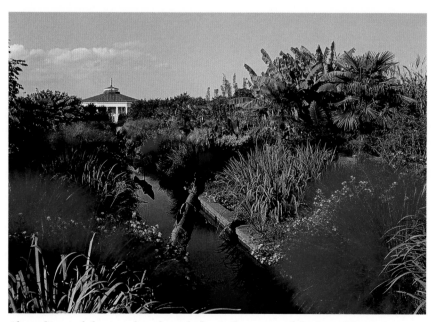

Along the canal that wanders through the garden rooms of the Daniel Stowe Botanical Garden, a new garden salutes the climate of Charlotte. DOUGLAS RUHREN

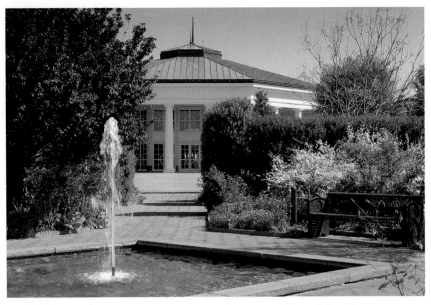

The afternoon may be warm, but the cooling fountain in front of the Administration Building entertains both eye and ear. MIKE BUSH

the garden resembles an Henri Rousseau painting, only lacking a sleeping gypsy and a threatening lion.

However hot the summer, winter is waiting in the wings, so executive director Mike Bush, head gardener Doug Ruhren, and director of horticulture James Summey begin to pot up division and root cuttings of tender perennials and desired annuals, though many of the garden's plants are hardy in the Charlotte area without winter protection.

Also visit the Canal Garden, with its chain of linked garden rooms that allow you to wander for nearly a mile, with an eye to the Carolina blue sky above and the tropics at your feet.

The gardens are open seven days a week from 9:00 A.M. to 5:00 P.M., but are closed Thanksgiving Day, Christmas Day, and New Year's Day. There is a small admission charge.

The gardens are located just west of Charlotte close to the North Carolina–South Carolina border, outside the town of Belmont, and easily accessible from I-77 or I-85.

Davidson Arboretum

Davidson College, Davidson, NC 28035
(704) 894-2000
www.library.davidson.edu/archives/ency/arbor.asp

The Davidson Arboretum is a large part of the historic 450-acre campus. The arboretum began back in 1855, after some ladies of Davidson College suggested some landscape remodeling in a letter to the board of trustees. By March 8, 1861, one W. N. Dickey (Class of 1860) wrote a letter to his friend Joe, saying: "Hurra for Davidson College! Great Excitement! Water running up hill! Earthquake! Shipwreck! etc. etc. & & & If some of the ancient worthies who established this institution, then a college in the woods, had passed by here today, they would have said that their manual labor system was still in force. All hands were turned loose this morning to plant trees . . . [with] the students ambition to perpetuate their names here was universal and all the students worked faithfully . . . [they] not only plant trees for themselves but for their sweethearts [and] plant[ed] 22 trees."

The trees grew and more were planted, so by 1869 the faculty proposed to the board of trustees that the college grounds become an arboretum. Even future president Woodrow Wilson is said to have planted a tree during his

A large part of the 450-acre campus of Davidson College is dedicated to trees, and the present Arboretum provides sanctuary for more than 1,650 of them. DAVIDSON COLLEGE

time as a student at Davidson, bringing a tree from the woods and planting it correctly.

In 1986 Davidson announced itself as a full-fledged arboretum. In 1989 Hurricane Hugo destroyed some 231 trees, and ice storms have also taken their toll, but strolling underneath these carefully labeled specimens, you'd never know what's missing, and the arboretum has continued to flourish. Today there are over 1,650 major trees, all identified, on 365 acres.

Davidson College is located 19 miles north of Charlotte, just off I-77 at Exit 30. For visitors, parking is available in the lots designated on the maps by a V within a yellow circle.

Durant Park

8305 Camp Durant Rd., Raleigh, NC 27614
(919) 870-2871
www.visitraleigh.com/durant_nature_park.html

The state of North Carolina is blessed with having natural landscapes that often resemble a garden created by the hand of man. Though quite often the hand is stilled because of budget cutbacks and public indifference, Durant Park is an example of what might replace malls or parking lots.

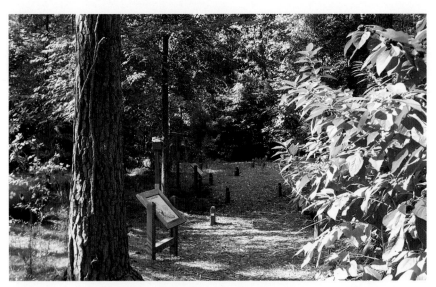

Although not a formal garden, Raleigh's Durant Park is another example of a large natural area devoted to flora and fauna with an interpretive nature program.

Featuring 5 miles of well-kept trails to scenic overlooks, two lakes, a stream, and a mix of pine and hardwood forests, open meadows, wildflowers, and ferns, Durant Nature Park is a 237-acre city parkland established in 1979 to give the citizens of Raleigh and Wake County an opportunity to interact with the diversity of nature in the lower Piedmont region. The park's many educational programs are designed to be enjoyable to the students and also enhance the school science curriculum. In addition, the park offers a variety of outdoor educational experiences and rental facilities. The Nature Resource Room has trail maps, Trail of Trees maps, and bird lists. An interpretive nature program is available.

Durant Park is open year-round from 8:00 A.M. to sunset. It's located in northeastern Raleigh, off of U.S. 1 north. Turn west onto Durant Road and go 1 mile.

Elizabeth Holmes Hurley Park

Lake Dr. at Annandale Ave., Salisbury, NC 28814
(704) 638-4459
www.salisburync.gov/hurleypark

Whether you view Elizabeth Holmes Hurley Park in winter, with a light dusting of snow silhouetting the shingled roof of the gazebo, or in late summer, when the brilliant Japanese maple 'Bloodgood' begins to shed its leaves in preparation

for the winter ahead, park curators Daphne Beck and Lana Bird welcome you to this 15-acre haven for reflection.

The park includes a collection of hollies and magnolias, a wildflower garden, an azalea garden, and many other plantings providing year-round interest and beauty. Finely crafted cypress benches and tables, specially designed bridges, and distinctive gazebos enhance the gardens, and you'll also find woodlands, streams, and pathways.

The park began as a joint venture between public funds and private interests in May 1984 in

At Elizabeth Holmes Hurley Park, the brilliant leaves of a fabled Japanese maple known as 'Bloodgood' fall and scatter along the pathway to the bridge. ELIZABETH HOMES HURLEY PARK

order to set aside a parcel of urban land for an area devoted to plants and wildlife for lovers of the great outdoors. A master plan was created by landscape architect Jane Ritchie, and a dedicated city staff and devoted volunteer committee continue to work together to implement this plan. In October 1985 the James F. Hurley family made a generous donation to the city in a dedication to their beloved wife and mother, Elizabeth Holmes Hurley.

The Hurley Park Division is responsible for the horticultural management of the park, including the development of all gardens in the park following the master plan, maintaining these gardens and other common areas of the park, urban forest management, and maintaining the park as a sanctuary for nature.

The park is open daily from dawn to dusk.

From I-85, take Exit 76 (Salisbury). Turn left off of the exit ramp, and proceed on West Innes Street until it intersects Fulton Street. Turn right on North Fulton Street and continue until the street ends; then turn left onto Lake Drive, which runs directly by Elizabeth Holmes Hurley Park.

Ellen Mordecai Garden

Mordecai Historic Park
1 Mimosa St., Raleigh, NC 27604
(919) 857-4364
www.raleighnc.gov/mordecai

In the late 1700s the Mordecai house and grounds formed one of the largest plantations in Wake County. Today the house remains one of the oldest residences in Raleigh and is the oldest house to still stand on its original foundations. Originally built in 1785 by Joel Lane, the house was named for Moses Mordecai, who married twice into the Lane family. The Mordecais were prominent in local and state affairs, and their furnishings and effects remain on exhibit in the main house at the park. Before his death in 1824, Moses Mordecai hired William Nichols, then state architect, to enlarge the original house. This addition is considered a significant work of Nichols and transformed the house into a Greek Revival mansion.

According to Troy Burton, director of the estate, the accompanying Ellen Mordecai Garden and Orchard is a reconstruction of a nineteenth century garden described by that lady in her reminiscences of her life at the plantation, published as *Gleanings from Long Ago*. "The garden," says Mr. Burton, "was opened to the public in May 1974. It contains a vegetable bed in the center, bordered in the outside beds by herbs, perennials, old roses, and many native

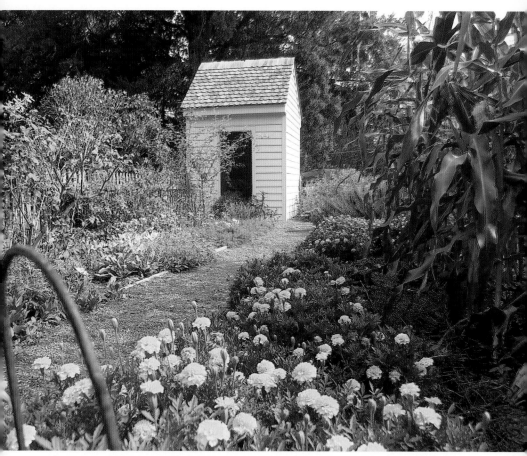

The gardens of Ellen Mordecai Historic Park contain vegetables, herbs, perennials, old roses, and many native wildflowers, all planted with an eye to beauty and organization. ELLEN MORDECAI GARDEN

wildflowers. The garden contains old plant material known to have been available in the nineteenth century. The orchard contains old peach, apple, and cherry trees also described by Ellen Mordecai. The plants and trees are labeled for visitor identification. The garden and orchard are located in the middle of the park, directly behind the Allen Kitchen, and contain an authentic garden toolshed in one corner." And, I might add, cuttings taken from the garden are for sale at the gift shop.

Mordecai Historic Park buildings and gift shop are open Tuesday through Saturday from 9:00 A.M. to 4:00 P.M. and Sunday from 1:00 P.M. to 4:00 P.M. The park grounds and garden are open from one hour after sunup until one hour before sunset every day. Tours of the grounds are available for a small fee.

Fearrington Village Gardens

2000 Fearrington Village, Pittsboro, NC 27312
(919) 542-2121
www.fearrington.com

Welcome to Fearrington Village, a community known not only for its history and its gardens, but also for a small ad in the *New Yorker* that featured black and white Galloway cows grazing around the pastures of the community. The village's estates are located on farmland with a history dating back to 1786, when one William Cole staked a 640-acre claim on the land. Today more than 1,800 residents live in this village, about 8 miles from Chapel Hill. The estates' present history began in 1974, when R. B. Fitch and his late wife, Jenny, purchased the now two-centuries-old dairy farm from Jesse Fearrington, who had inherited the farm from his great-great-grandfather William Cole. The Fitches slowly built this unique community from the rolling pastures and wooded acres of the farm.

One of the delights of Fearrington Village is to visit the gardens and wander the grounds. The village's many gardens include Jenny's Fragrant White Garden; the Perennial Border garden, site of many weddings; the Herb Garden, used by the award-winning Fearrington House restaurant; the inn's English Courtyard and Knot Garden; the Wildflower Garden; and the very informal southern garden at the Old Granary Restaurant and Bar.

Fearrington Village is open to visitors seven days a week year-round, and visitors are welcome to stroll through the many gardens at any time. Take I-40, getting off at Exit 218A (U.S. Route 220). Drive 2 miles, then exit on NC Route 78 toward Raleigh-Durham. Then exit at 126A (U.S. Route 421 south)

Fearrington Village Gardens include many of the features found in the best English gardens, including trimmed boxwoods, a great knot garden, and a lovely garden of all white blossoms. FEARRINGTON VILLAGE

The White Garden at Fearrington features all sorts of white annual and perennial flowers and is especially beautiful under a full moon. FEARRINGTON VILLAGE

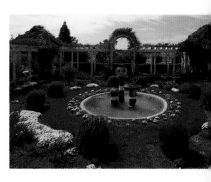

toward Sanford. Take Exit 171 off U.S. Route 421 at Siler City to U.S. Route 64 east. Take Exit 383 off NC 64 east at U.S. Route 15-501N. Follow U.S. Route 15-501 north for 6 miles to Fearrington.

Flora Macdonald Gardens

200 S. College St., Red Springs, NC 28377
(910) 843-5000
www.capefearscots.com/campus.html

"Whaur ar ye frae?" is a perfect question to ask a visitor to the Flora Macdonald Campus and Gardens. And whatever state or country you hail from, there's a Scottish history to this place (beginning with the Annual Flora Macdonald Highland Games), all delightfully served up with the phrase "southern hospitality with a taste of Scotch."

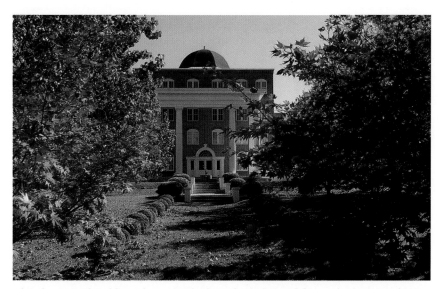

The Flora Macdonald Academy was built in the 1800s and features ten acres of gardens. Always known for the azalea collection, the gardens were fully restored after a tornado hit in 1984. FLORA MACDONALD GARDENS

The buildings and grounds of this campus began in 1896, when Dr. Charles Graves Vardell, a Presbyterian minister, founded a new school with the name of Red Springs Seminary. In 1914 the name changed to the Flora Macdonald College, in honor of the famous Scottish heroine who, for a time during the Revolutionary War, lived in this part of North Carolina.

The gardens, which measure about 10 acres, were originally started by Dr. Vardell and soon became nationally known under his direction. A tornado in 1984 was responsible for a great deal of damage to the gardens, but today as you wander the pathways, you would never know. As part of the restoration, many new plant specimens were added, along with replacements for plants lost to the storm. The gardens, always renowned for the variety of azaleas in the spring, still feature many of the plants originally gathered by Dr. Vardell.

Whatever time of year you choose to visit the campus, you will find a tranquil place to relax and enjoy some of God's most beautiful creations.

The gardens are open November 1 to March 31 from 9:00 A.M. to 5:00 P.M. and April 1 to October 31 from 9:00 A.M. to 6:00 P.M. There is no admission fee.

Take Exit 41 from I-95 south to U.S. Route 301 to NC Route 71 through Parkton.

Greensboro Arboretum

W. Market St. and Ashland Dr., Lindley Park, Greensboro, NC 27402
(336) 373-2199
www.greensborobeautiful.org/Arboretum.htm

Completed in 1991, the Greensboro Arboretum began as a cooperative effort of the city's Parks and Recreation Department and Greensboro Beautiful. Open all year round, the 17-acre site features twelve permanent plant collections that are especially valuable to new homeowners who wish to establish gardens but have no idea how some plants will look and grow a few years down the line.

The arboretum includes a great collection of conifers, often a surprise to new southern gardeners who've moved south from the chilly North; the Groundcover Collection, an especially great exhibit for gardeners who eschew lawns; the William R. Findlay Sun Shrub Collection, dedicated to plants that do well in full sun; the Irene H. McIver Vine Collection and Perennial Border, an exhibit that features a variety of climbing plants trained to grow on the landmark arbor, which is surrounded by a 4-foot border of perennials providing spring, summer, and fall beauty; and the Wildflower Trail, a wooded trail lined with native wildflowers and ferns that provide interest in all seasons. My

The Greensboro Arboretum was completed in 1991 and features many collections, including conifers, vines, and shrubs. The kiosk at left tells of the current garden highlights. GREENSBORO PARKS & RECREATION DEPARTMENT

favorite is the Greensboro Council of Garden Clubs Winter Garden Collection, with plants of interest during the winter months and a gazebo for weddings, meetings and relaxation. In addition, look for the R. R. Allen Family Butterfly Garden and the Beeson Rhododendron Garden, with more than seventy varieties blooming from May to late June. If roses are your favorite, there's a first-class collection developed and maintained by the Greensboro Rose Society.

The gardens are open year-round from sunrise to sunset.

To reach the Greensboro Arboretum, take a right from I-40 onto West Wendover Avenue, then a left onto West Market Street.

Greensboro Bicentennial Garden and The Bog Garden

1105 Hobbs Rd., north of Friendly Ave., Greensboro, NC 27405
(336) 373-2199
www.greensborobeautiful.org/TheGardens.htm

I've linked the Greensboro Bicentennial Garden and The Bog Garden because they're right across the street from each other. The first garden was created in 1976 to commemorate the nation's bicentennial, and the second is rather more unusual, as it's a salute to plants that delight in boggy conditions.

Today the Bicentennial Garden is a thriving landmark and destination for area residents and visitors. The grounds feature a wide variety of plantings, including ground covers, shrubs, masses of annuals and perennials, and both flowering and canopy trees.

To complement the natural settings, a wedding gazebo adds an air of elegance; a man-made recirculating stream provides texture, movement, and sound, and a sensory garden engages visitors in an interactive landscape experience. A wide variety of sculpture placed throughout the garden provides artistic and historic interest.

If garden structure and formality are not high on your list of priorities, simply walk over and visit The Greensboro Bog Garden. An elevated boardwalk comprises half a mile of the just-over-a-mile-long trail that winds through this unusual garden. Along the trails you will find an amazing selection of wetland flora, including trees, shrubs, wildflowers, and a host of fern species, all thriving in a wetland ecosystem. The Bog Garden also provides an excellent place for viewing wetland wildlife, such as migratory and indigenous birds. A beautiful water feature has been recently added to this lush green landscape, contributed by Greensboro's local art community.

Greensboro's Bicentennial Garden was created in 1976 to commemorate the nation's 200th birthday. Today it features a wealth of plantings from flowering annuals and perennials to shrubs and flowering trees. GREENSBORO PARKS & RECREATION DEPARTMENT

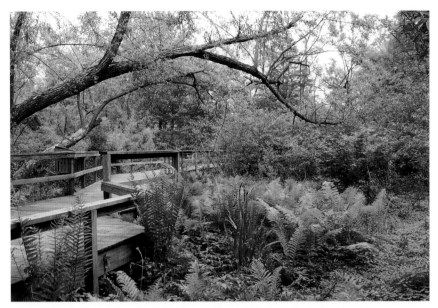

The elevated boardwalk allows visitors to look out on a host of ferns, shrubs, trees, and wildflowers that thrive in a wetland ecosystem. GREENSBORO PARKS & RECREATION

Benjamin Lake Overlook is a popular destination where migrant waterfowl often overnights—or sometimes spends weeks—because the garden is such a peaceful place to be. Whether seeking migrant birds or just feeding the resident ducks, geese, and turtles, all visitors find something to enjoy about the overlook.

The gardens are open year-round from sunrise to sunset.

To reach the Bicentennial and Bog Gardens, turn off I-40 onto West Wendover Avenue. Turn on West Friendly Avenue, then right on Hobbs Road.

JC Raulston Arboretum

4415 Beryl Rd., Raleigh, NC 27606
(919) 515-3132
www.ncsu.edu/jcraulstonarboretum

I've had the honor of serving on the board of the JC Raulston Arboretum and can write firsthand about this marvelous arboretum and lush public garden dedicated to plants, education, and introducing plants for the public and private gardens of the Southeast. A young Dr. JC Raulston, working with a great staff, turned the original 8-acre plot of land into a salute to the concept of the garden room.

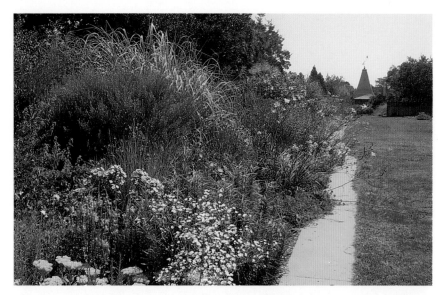

The Great Perennial Border, some 300 feet long and 18 feet deep, is just one of the highlights at the JC Raulston Arboretum. JC RAULSTON AROBORETUM

There are four main areas of interest. The elegant Klein-Pringle White Garden was modeled after Sissinghurst, Vita Sackville-West's garden in Kent, England. The predominant feature is white, seen both in flowers and in variegated and silver foliage set against dark backgrounds of hollies and conifers. The Great Perennial Border, which is 300 feet long and 18 feet deep, consists of an eclectic mix of herbaceous perennials, bulbs, small shrubs, and sweeping ornamental grasses designed to blare forth with a profound display of texture, color, and form whatever the season of the year. The Finley-Nottingham Rose Garden displays more than 120 varieties of climbers, hybrid teas, shrubs, and native roses of all types both old and new. The Mixed Border is 300 feet long and 15 feet wide, with superior plants bred by the arboretum for the climate of the Southeast. This border is a tapestry of small garden vignettes and features all the elements that make up a successful garden.

The JC Raulston Arboretum is free and open to the public 365 days a year. Hours are April through October from 8:00 A.M. to 8:00 P.M. and November through March from 8:00 A.M. to 5:00 P.M.

To reach the arboretum take I-40 east to Raleigh, and get off at Exit 289 to Wade Avenue. Take the second exit off Wade Avenue to turn right on Blue Ridge Road. At the third traffic light, turn left on Hillsborough Street. Drive under the Beltline, and turn right onto Beryl Road, by the Waffle House. Go over railroad tracks (bearing to the right), and continue straight ahead for about .5 mile. There are signs.

The white pavilion at the JC Raulston Arboretum allows the visitor to stop and look out at a fantastic collection of trees, shrubs, and perennials that thrive in the warm summers around Raleigh. JC RAULSTON ARBORETUM

Juniper Level Botanic Garden

Plant Delights Nursery, 9241 Sauls Rd., Raleigh, NC 27603
(919) 772-4794
www.plantdelights.com

The Juniper Level Botanic Gardens are part of Tony Avent's Plant Delights Nursery, located in southern Wake County, about eighteen minutes south of Raleigh. Don't let the word *nursery* throw you off. Yes, plants are for sale, thank heavens, but these are really display gardens with a master horticultural mind doing the conducting.

The gardens were created in the summer of 1988, when Tony and Michelle Avent moved to this 2¼-acre plot. The new property consisted of a recently constructed house in the middle of a tobacco field, with a vine-engulfed swamp to the south, where, as in a minor horror film, deceased farm implements were buried. The gardens are named after an old nearby community called Juniper Level, the name originating from the native junipers (*Juniperus virginiana*) that once grew close by. Tony has continued to add all sorts of theme gardens, including a rock garden, a scree-bed garden, a woodland garden, and a bog-and-aquatic garden complete with a high constructed mound that supports a waterfall and is a great place to sit and ruminate.

The displays found at the Juniper Level Botanic Garden feature rare and beautiful plants and an inherent sense of design that would be welcome in any garden of the Southeast.

Tony does have a sense of humor, in addition to knowledge of some of the odder plants that will grow in a well-kept garden, as the following entry in his catalog demonstrates: "Did someone mention aroids? I thought I heard you. For our fall list, we have added ten new amorphophallus in honor of our visit and lecture from the world's amorphophallus expert, Wilbert Hetterscheid of the Netherlands. We've also added a couple of cool new dwarf hardy elephant ears, *Colocasia fallax* 'Silver Dollar' and *Colocasia heterochroma* 'Dark Shadows'."

The nursery has four open house days each year, with open sale days limited to eight weekends per year—two each in winter (February–March), spring (May), summer (July), and fall (September); anyone can come during the posted hours without an appointment. If you will be coming from out of town during nonscheduled open days or would like to bring a group, call well in advance, and the staff will be delighted to try to make arrangements to schedule a visit. Never drop in unannounced.

Take I-40 east to U.S. Route 401 south (exit 298). Take U.S. Route 401 south to the intersection of Ten Ten Road at the stoplight by McDonald's. Turn left, go 4 miles, and then turn right on Sauls Road. The nursery is 1 mile on the left.

Memorial Garden

50 Spring St. SW, Concord, NC 28026
(704) 786-8009
www.concorddowntown.com/pages/cddc_memorial-gardens.html

Located in the center of historic Concord, the Memorial Garden consists of 3 acres of lovely gardens linked with the 200-year-old cemetery of the First Presbyterian Church. No matter what the season, this is a lovely place to visit.

Would that Walt Whitman had written a poem celebrating these gardens. Had he done so, perhaps more citizens of the area and visitors to Statesville, Charlotte, and Concord would spread the word about just what is available on this site, including the 14,000 tulips and spring bulbs that are planted each fall and burst forth in late March and early April, as well as azaleas, dogwoods, grand flowering cherries, and both common and rare perennials.

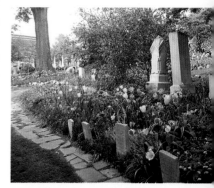

The Memorial Garden grows throughout the 200-year-old cemetery of the First Presbyterian Church and is a salute to the continuing belief in the human spirit.
JUDITH VAN NOATE

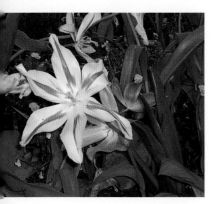

The garden features 14,000 tulips and spring bulbs that burst forth in late spring. Here is the bloom of an aging tulip, its striped petals saluting the warming sun of spring. JUDITH VAN NOATE

When entering the cemetery, you'll see a semicircular brick structure with a lion's head fountain over a small pool, headstones, and colorful floral displays. Walking on down the winding pathways, you'll see more gravestones and various sculptures. These are not the kinds of gravestones found in the marble shops often located right down the road from a groomed and manicured cemetery that features plastic flowers in tin jardinieres.

The Memorial Garden features roses, fountains, garden arches, benches to rest weary feet and frayed souls, a waterfall, camellias in late winter, and wildflowers throughout. At the top of the steps, you can go to the right and see the sundial overlook, which was originally the site of the two churches. A narrow pathway leads to the waterfalls and a fishpond, with a statue of St. Francis. About the only salute to life and the garden missing from this site is a statue of St. Fiacre, the patron saint of gardening.

When you arrive, pick up a guide, which shows the layout of the garden. A generous endowment from the Phiffer family has maintained the garden, the same family that George Washington visited on his farewell tour of the South.

The garden is open Monday through Saturday from 9:00 A.M. to 5:00 P.M. and Sunday from 1:00 to 5:30 P.M. Admission is free, but donations are accepted. The place is absolutely wonderful for weddings. I-85 and I-77 are minutes away from downtown Concord.

North Carolina Botanical Garden

Old Mason Farm Rd., Chapel Hill, NC 27517
(919) 962-0522
www.ncbg.unc.edu

The North Carolina Botanical Garden is, in the words of a savvy plant lover, a big deal. When the land responsibilities are all added up, the garden in toto consists of nearly 800 acres, including the Coker Arboretum in the heart of the UNC–Chapel Hill campus and the 367-acre Mason Farm Biological Preserve, a place that is used for scientific research and teaching and is accessible by permit only.

The Botanical Garden dates back to 1903, when Professor William Chambers Coker began planting trees and shrubs on the central campus, now Coker Arboretum. In 1952 the trustees dedicated more land at the south edge of the campus and development began, continuing today.

Visitors to the nearly 10 acres of display gardens on Old Mason Farm Road will encounter the Habitat Display Gardens (both Mountain and Coastal Plain), the Carnivorous Plant Collection, native perennial borders, the Mercer Reeves Hubbard Herb Garden—in fact, a rousing sample of just about everything that's obtainable and grows in North Carolina and often the Southeast.

The Herb Garden is home to some 500 species, including 52 cultivars of rosemary (*Rosmarinus officinalis*) and is laid out in several sections: a culinary garden, an economic garden, a medicinal garden, a Native American garden, and for a garden of last resorts, the poison garden.

If herbs leave you less than fired up, turn to the Carnivorous Plant Collection, remembering that North Carolina was the original home of the Venus-flytrap plant (*Dionaea muscipula*), first discovered by Arthur Dobbs, an early governor of the state.

In addition, there's the Paul Green Cabin, where the North Carolina native and Pulitzer Prize–winning author for the Broadway play *In Abraham's Bosom*, kept his notes and observations on life, language, and plants.

The gardens are open Monday through Friday from 8:00 A.M. to 5:00 P.M. Saturday from 9:00 A.M. to 6:00 P.M., and Sunday from 1:00 P.M. to 6:00 P.M.

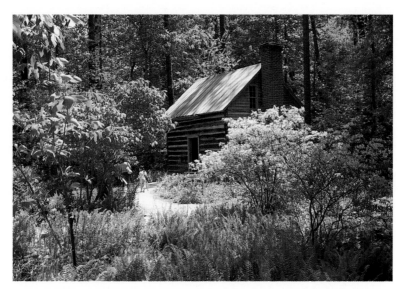

The Paul Green Cabin on the campus of the North Carolina Botanical Garden is a memorial to the Pulitzer Prize-winning author of In Abraham's Bosom. NORTH CAROLINA BOTANICAL GARDEN STAFF

During non–daylight saving time periods in late fall and winter, closing time is 5:00 P.M. on weekends.

From I-40, get off at Exit 273 and take Route 54 west to Chapel Hill. Travel 2.4 miles, and turn left at the traffic light onto Finley Golf Course Road. Go .6 mile and curve right onto Old Mason Farm Road.

Oak View Herb Garden

4028 Carya Dr., Raleigh, NC 27610
(919) 250-1013
www.wakegov.com/locations/oakview.htm

If Pam Beck had not clued me in, I would have driven right by this small but delightful garden right off Raleigh's Beltway. And I never would have been introduced to a lovely old house, a near-perfect herb garden, and one of the most instructive displays I've ever encountered on the extent and know-how of cotton production around the Piedmont.

Originally founded in the late 1830s and including more than 900 acres, historic Oak View remains as a 17-acre site that offers a glimpse into the past while the swishing sounds of twenty-first-century America driving the Beltway on the other side of the trees underlines just how fast history has sped by.

Standing with a regal élan, the original farmhouse was built in 1855 by Benton S. D. Williams in the Greek Revival style, as seen in the front columns and double portico porch. During the 1940s, the Poole family renovated the home, building an addition in the Colonial Revival style.

Completed in 1997, the Farm History Center is the newest building on the grounds. It's dedicated to telling the story of North Carolina's agricultural development, from colonial times to the present, through programs and interactive exhibits. Also on the site is a lovely pecan grove, the largest in Wake County. This grove has been hit by two hurricanes, Hazel in 1954 and Fran in 1996, but seventy new saplings were planted in 1997. Another feature is a beautifully structured herb garden, classic in every detail and maintained by volunteers from the Wake County Herb Society.

The gardens and grounds are open from 8:30 A.M. to one hour before sunset, seven days a week. The buildings are open Monday through Saturday from 8:30 A.M. to 5:00 P.M., and Sunday from 1:00 P.M. to 5:00 P.M. The Main House is closed on Mondays, and the entire estate is closed on Thanksgiving, Christmas Eve, Christmas Day, and New Year's Day.

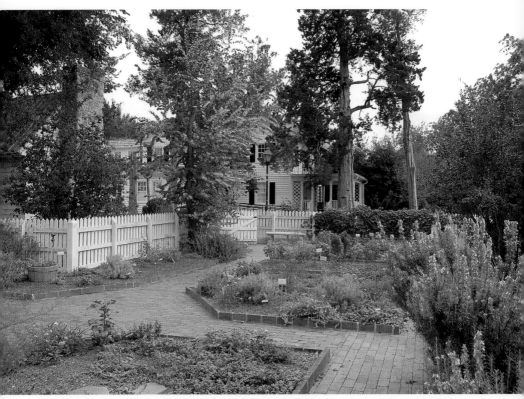

The Herb Garden that graces Historic Oak View Park features many plants found in gardens of long ago, with herbs that feature scent, texture, and amazing medicinal uses.

From the I-440 Beltline, take Poole Road Exit 15 and head east toward Zebulon (away from downtown). Look for the white fence on left. Turn left into Carya Drive, and follow the Historic Site markers into the park.

Reynolda Gardens

100 Reynolda Village, Winston-Salem, NC 27106
(336) 758-5593
www.wfu.edu/gardens

The Reynolda Gardens, now owned by Wake Forest University, consist of 4 acres within the present 129-acre Reynolda Estate grounds. The gardens were originally part of a large country estate and farm totaling 1,067 acres, created by tobacco baron Richard Joshua Reynolds and his wife, Katharine, between

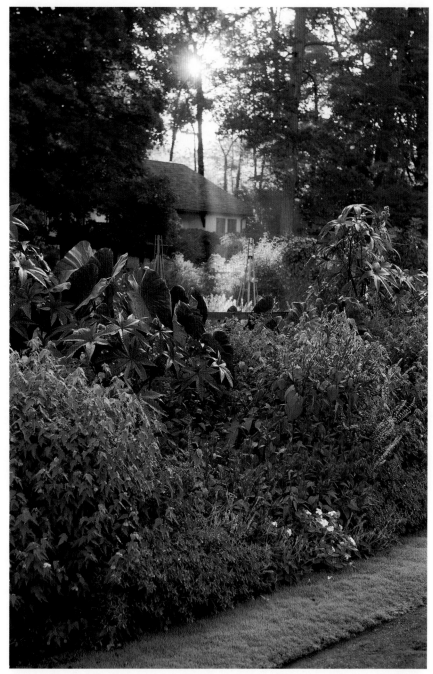

The gardens at Reynolda Gardens of Wake Forest University include roses, specimen trees, theme gardens, and well-cared-for boxwood hedges. Here the border includes many tropical plants. ©WFU/KEN BENNETT

1906 and 1923. In 1913, a Lord and Burnham greenhouse was constructed to produce flowers for the commercial market.

In 1924, after the death of Mrs. Reynolds, most of the property was either sold or given away including 300 acres deeded to Wake Forest College. In 1962, daughter Mary Reynolds Babcock founded Reynolda Gardens by donating its property to the college. In 1995 the college, assisted by the National Park Service, performed extensive reconstruction based on a historic model and returned the garden to its original design.

Today the gardens include woodlands, wetlands, fields, and a 4-acre formal garden including a greenhouse. Two acres of the formal design encompass the Greenhouse Gardens, centering about a sunken garden that is divided into four quadrants, as well as a large rose garden, theme gardens, mown lawns, specimen trees, and boxwood hedges. In spring the Japanese weeping cherries put on a dazzling show. Look for a tea house, fountains, and pergolas. The other half of the property consists of the Fruit Garden, Cut Flower Garden, and Nicer Vegetable Garden, which includes vines, vegetables, climbing roses, and espaliered fruit trees.

The property also has a ³/₄-mile woodland trail and a slightly longer perimeter trail of about 1¹/₂ miles.

Reynolda Gardens are located off Reynolda Road, adjacent to the Reynolda campus of Wake Forest University in Winston-Salem. By car from I-40 Business, take Silas Creek Parkway north for about 4 miles, and bear right at the Wake Forest University exit. Turn right at the stoplight at Reynolda Road, then left at the first stoplight, entering Reynolda Village at By Way Street.

Sandhills Community College Gardens

3395 Airport Rd., Pinehurst, NC 28374
(910) 695-3882
www.sandhills.cc.nc.us/lsg/hort.html

When I researched information on the Sandhills Community College Gardens, I spoke to Dee Johnson, the coordinator of the landscape gardening program, who told me that the development of any garden was a logistic effort that required the three dictates of any garden design: location, location, and location. And if you live in the central part of the state, a great place to check out these dictums is Sandhills.

Sandhills Community College was chartered in late 1963. Five years later the Landscape Gardening School was initiated. Then in 1978 the Sandhills

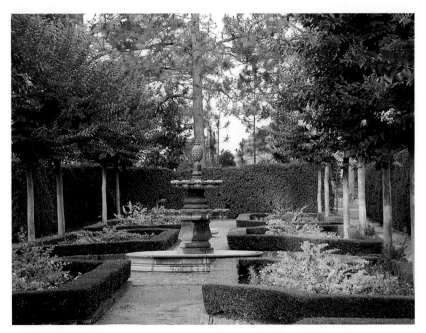

The formal English-style garden at Sandhills Community College salutes Sir Walter Raleigh and the attempted colonization of Roanoke Island in 1584.
SANDHILLS COMMUNITY COLLEGE GARDENS

Horticultural Gardens became a reality with the establishment of the Ebersole Holly Garden. Today the gardens cover 27 acres.

Conifer collections are important in the Southeast, because gardeners moving here from cooler areas of the country often mistakenly believe it's too hot for needled trees. The collection at Sandhills features many varieties of slow-growing conifers that reflect their many nuances of color, amazing forms, and delicate and sharp textures—and they withstand high heat.

The Sir Walter Raleigh Garden occupies more than an acre of land. It's a formal English garden designed and constructed to commemorate the attempted colonization of Roanoke Island in 1584. The Raleigh collection includes several minigardens, such as the Holly Maze, Fountain Courtyard, Sunken Garden, Ceremonial Courtyard, and Herb Garden. The Atkins Hillside Garden includes a winding river rock stream with five bridges, waterfalls, pools, and a falls overlook, just to open gardening minds to what you can do in your own backyard.

The gardens are open from daylight until dark year-round, and admission is free.

Take I-40 south of Statesville, and get off at the third U.S. Route 64 exit south to Mocksville, about 14 miles from Statesville. Stay on U.S. 64 to Asheboro. Outside Asheboro, exit right onto U.S. Route 220 south and take this

highway to Candor. Take the Pinehurst exit off U.S. 220 onto NC Route 211 south, and proceed to traffic circle outside Pinehurst. Enter the traffic circle in the left lane, and exit in the left lane at the third exit onto NC Route 5 at the Sandhills exit. Move to the left lane after exiting the circle, and bear left onto Airport Road. After 2 miles, you will pass the main entrance to Sandhills on your right. Continue 500 yards past the main entrance to the Visitor Center.

Sarah P. Duke Gardens

426 Anderson St., Box 90341, Duke University, Durham, NC 27708
(919) 684-3698
www.hr.duke.edu/dukegardens/index.html

The Sarah P. Duke Gardens encompass 55 acres on the West Campus of Duke University, not far from the famed Duke Chapel, itself worth a visit. The gardens were created in 1934 to honor the memory of the wife of Benjamin N. Duke, one of the university founders.

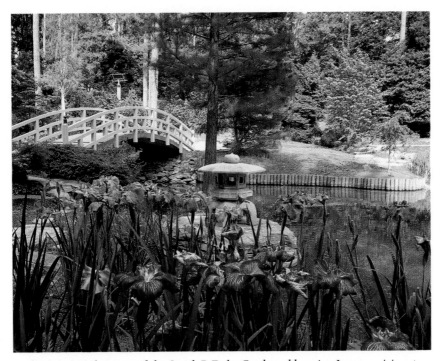

In the Asiatic Arboretum of the Sarah P. Duke Gardens, blooming Japanese iris act as floral screens for an antique stone lantern and complement the color of the Iris Bridge at left. SARAH P. DUKE GARDENS

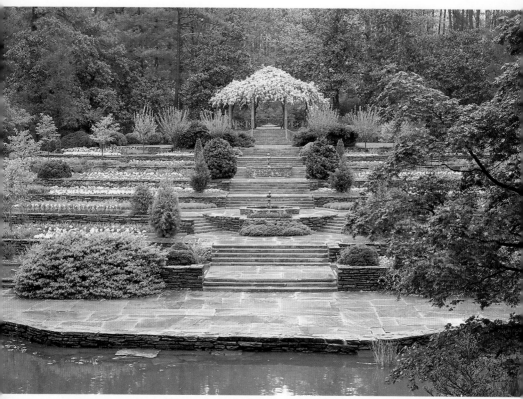

The historical core of the gardens is best exemplified by the series of grand terraces, which are beautiful to see throughout the year, but are especially striking when the wisterias are in bloom. SARAH P. DUKE GARDENS

The historical core of the gardens is a series of grand terraces designed by the distinguished landscape architect Ellen Biddle Shipman (1869–1950), who designed more than 650 gardens throughout the country between 1914 and 1950. Shipman melded elements from the Colonial Revival and the Arts and Crafts movements into grand designs, one of the more imaginative being this garden at Duke, now a national architectural treasure.

Today the gardens consist of four major parts: the original terraces and their immediate surroundings, incredibly beautiful when the wisteria vines are in bloom; the H. L. Blomquist Garden of Native Plants, with its representation of the flora of the southeastern United States; the Doris Duke Center Garden, with 5 miles of allées, walks, and pathways; and the Culberson Asiatic Arboretum, devoted to plants of eastern Asia. This last garden showcases Chinese, Korean, and Japanese trees and shrubs suitable for southeastern gardens. Whether your visit is for study or to get ideas for creating your own Asian garden, this arboretum is an amazing salute to the styles of oriental gardening and

surely the best such display short of traveling to the Northwest or the gardens in the Missouri Botanical Garden.

The gardens are open daily from 8:00 A.M. to dusk. There is no admission fee.

Take I-40 west to the NC Route147 (Durham Freeway) split. Follow Route 147 into town, exit, and turn left on Swift Avenue. At a four-way stop, turn right onto Campus Drive; then proceed to the first stoplight and turn right onto Anderson Street. The main entrance is 150 yards on your left after the intersection. Look for a half-circle drive with stone walls.

Tanglewood Botanical Gardens

4061 Clemmons Rd., Clemmons, NC 27012
(336) 703-2850
www.tanglewoodgardens.org

Like many public gardens in North Carolina, Tanglewood began its history as land claimed by Sir Walter Raleigh for Queen Elizabeth on March 25, 1584. One of the original settlers was William Johnson, an emigrant from Wales. In 1757, just four years after the Moravian settlement of the Wachovia Tract, Johnson purchased a square-mile area of present Tanglewood Park. There he

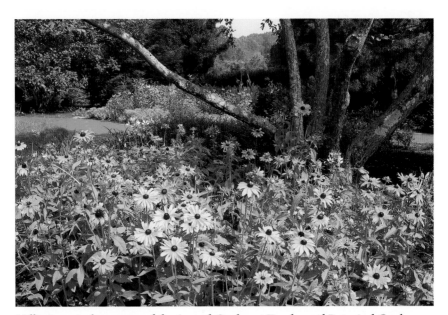

Millie Jones is the curator of the Annual Garden at Tanglewood Botanical Gardens, a great place to see the sheer variety of annuals flowers available to today's gardener.
CONNIE LITTLE

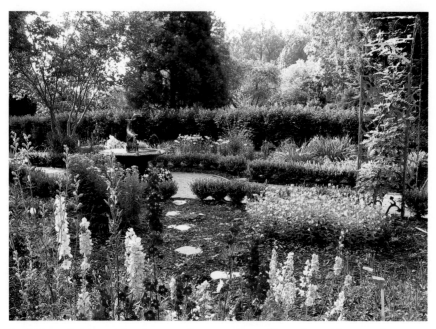

Larkspurs, thriving under the care of curator Gay Nell Hutchens, bloom in the Friendship Garden at Tanglewood. CONNIE LITTLE

built a fort overlooking the Yadkin River to protect family and friends from attack during the French and Indian War.

Years passed, and Tanglewood went from being a home for some of America's finest Thoroughbred harness horses and pacers to becoming a gift to Forsyth County as a park and playground. In the 1970s the Garden Council of Winston-Salem became active in restoring the arboretum at Tanglewood Park. In 1981 landscape architect Roy Pender was hired to develop a design for a park where the plants would thrive in Forsyth County's climate. In 2000 Forsyth County invited the Cooperative Extension Service to oversee the maintenance of the arboretum.

Today the arboretum consists of many well-tended, imaginatively planted theme gardens, including a great annual garden, a sumptuous azalea garden, and an herb garden with over 100 varieties, including more than 10 kinds of thyme, lavender, and eucalyptus. A groundcover garden was created to help local gardeners find and use substitutes for grass; a wildflower garden is maintained to identify and preserve significant native plants of Forsyth County and educate citizens about the importance of native plants to the home landscape; and a xeriscape garden teaches gardeners how to raise plants in an attractive environment with very little water.

The gardens are open Monday through Friday from 8:00 A.M. to 5:00 P.M.

Tanglewood Park is located only ten minutes from Winston-Salem on I-40 in Clemmons. Take I-40 West to Exit 182. Turn left on Harper Road; at the light, take a right onto U.S. Route 158. Tanglewood Park is .1 of a mile on the left.

UNC Charlotte Botanical Gardens

McMillan Greenhouse, 9201 University City Blvd., Charlotte, NC 28223
(704) 687-2364
www.gardens.uncc.edu/

One of the horticulturists responsible for the excellence of the UNC Charlotte Botanical Gardens is Dr. Larry Mellichamp, my coauthor on *The Winter Garden* (Stackpole Books, 1997). He is not only a master plantsman, but also an expert on the charms of carnivorous plants. And visiting these gardens will be a notable adventure, even with the other glories of North Carolina.

The gardens contain a great combination of outdoor and indoor facilities. There are three main garden areas. The 7-acre Van Landingham Glen is a woodland garden showcasing native plants of the Carolinas. It has the most diverse rhododendron gardens in the Southeast. The 3-acre Harwood Garden is another year-round attraction, with an impressive display of hardy ornamental landscape plants, wandering pathways, a pond with waterfalls, an oriental gazebo, and naturalistic rockwork throughout. The McMillan Greenhouse complex consists of eight "rooms" plus surrounding beds, terraces, and a courtyard bog garden featuring carnivorous pitcher plant hybrids. The greenhouse contains an outstanding orchid collection in addition to a rainforest conservatory, desert succulents, and many plants from the world's tropical habitats.

The gardens are open during daylight hours, seven days a week. The McMillan Greenhouse is open Monday through Saturday from 10:00 A.M. to 3:00 P.M. Greenhouse and garden visitor parking is located across from the greenhouse on Craver Road. That lot has several parking spots identified as garden and parking services for visitors. Park

The Vine Alley outside the McMillan Greenhouse at the UNC Charlotte Botanical Gardens is a riot of tropical exuberance all summer long. Many of the tropicals winter in the greenhouse. LARRY MELLICHAMP

Visit Nykie, the Deinonychus, *a dinosaur that has set up camp amid a display of primitive plants in the McMillan Greenhouse in the gardens at Charlotte.* LARRY MELLICHAMP

there and obtain a temporary parking permit from the office adjacent to the lot. These permits are needed Monday through Friday from 8:00 A.M. to 5:00 P.M.

Visitors unfamiliar with the university area should take I-85. Get off I-85 at Exit 46 east, Mallard Creek Church Road, and travel southeast (off I-85 south, that's a left; off I-85 north, that's a right). At the second stoplight, turn right onto Mary Alexander Road. You will enter campus; at the four-way stop, continue straight.

Weymouth Center

555 E. Connecticut Ave., P.O. Box 939, Southern Pines, NC 28388
(910) 692-6261
www.weymouthcenter.org/weymouthgardens.htm

Talk about history. Back in the mid-1980s Charlotte Gantz, doyen of the Weymouth Gardens, wrote the following letter to *Carolina Gardener* magazine:

> The gardens came into being in the early twenties when Weymouth Center for the Arts and Humanities was the home of James Boyd, a popular writer during the early part of the 19th Century. Following his widow's death, the property was acquired in 1976 by the Friends of Weymouth, and the house is now used

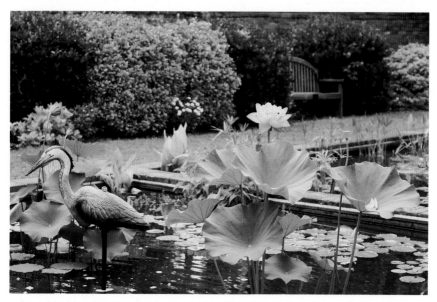

A lotus blooms while an artistic heron looks the other way in one of the two pools filled with tropical lotuses and water lilies. WEYMOUTH CENTER

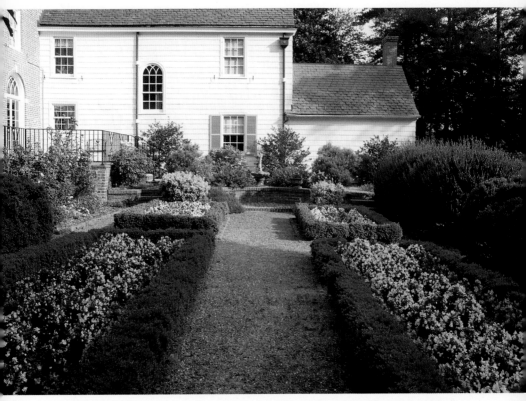

Weymouth Center has long been home to artists and writers of North Carolina. Above, the two long parallel beds filled with showy annuals and bulbs in bloom lead the way to the house, now used as a writer's retreat. WEYMOUTH CENTER

as a writer's retreat, as well as for the North Carolina Literary Hall of Fame. The original gardens were restored by Elizabeth Ives (Adlai Stevenson's sister) and Helen Greene, an active local gardener. Since then they have been kept up entirely by volunteers with financial help from the local garden clubs, the Carolina Writers and Poets Associations and generous private contributions.

One of the gardens' chief attractions is two long, parallel beds filled with perennials, showy annuals, and bulbs, frequently described as resembling an English cottage garden. Though they lack any formal planning, they are full of color from early spring to late fall. The beds lead toward two pools filled to the brim with tropical lotuses and water lilies, backed by a serpentine wall copied from Jefferson's home at Monticello, but recently discovered to be a product of the early twentieth century and not of Jefferson's design.

Sam Ragan (1915–96), a past North Carolina poet laureate, was very involved with Weymouth, and because of his influence and interest in support-

ing writers, two large areas, the Poet's Garden and the Writer's Retreat, have been planted for their benefit. There also are many smaller beds, some filled with hostas, some with herbs, and some with wildflowers. One acre is devoted to native trees and shrubs. And flowers that lure butterflies are found throughout the gardens.

The Boyd House is open to the public Monday through Friday from 10:00 A.M. to 2:00 P.M. Group tours are available. The gardens and grounds are open daily.

The garden are across the street from the Campbell House, home of the Arts Council of Moore County, and four blocks east of Broad Street, the Southern Pines business district.

Wing Haven Gardens

248 Ridgewood Ave., Charlotte, NC 28209
(704) 331-0664
www.winghavengardens.com

Since 1927, and its creation by Elizabeth and Edwin Clarkson, Wing Haven has been a special part of Charlotte. The gardens, enclosed on all sides by brick walls, encompass almost three acres in the heart of a lovely old neighborhood. The formal garden design is built around structured garden rooms and boasts long, uninterrupted views. Plantings consist of rare and exotic perennials, wildflowers, shrubs and vines (grown both for flowers and bird food), and wooded areas, necessary because birds are a featured element. In fact, throughout Wing Haven the emphasis is on plantings for birds, so the basic design provides protective cover, nesting sites, food, and water. Plaques and statuary are integrated into the garden walls and paths. In 1970 the Clarksons gave the gardens to the Wing Haven Foundation.

When Elizabeth Clarkson began her garden, she used plants that were available at the time, so a number of the original plants are now considered to be "exotics" and invasive in the Southeast. Where pest problems arose, native plants were introduced and the melding has been so smooth that nobody has ever noticed.

Part of the formal garden design is a classic herb garden, bordered with hundreds of oriental boxwoods, featuring four quadrants devoted to medicinal, culinary, fragrant, and biblical plants. Mrs. Clarkson installed 500 oriental boxwoods (*Buxus* spp.)—purchased for six cents each—to create the clipped hedge with rosemary (*Rosmarinus officinalis*), anchoring each of the quadrants.

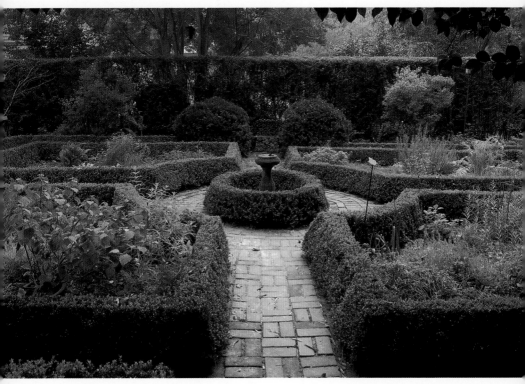

The Pomegranate Path leads to the center of the Herb Garden at Wing Haven, where the plants, shrubs, and vines are grown not only for beauty but also for bird food.
JEFF CRAVOTA

The sundial, a wedding gift to the Clarksons, keeps perfect time on sunny days and adds a sculptural accent when clouds abide.

At the bottom of the lower path is a statue of St. Fiacre, patron saint of gardeners. Born in Ireland in the seventh century, he founded a monastery in France where he was revered for his healing herbs and the vegetables he raised to feed the poor. St. Fiacre is always depicted with a spade and the fruits of his labor in his hands—a perfect saint for Wing Haven.

Wing Haven is open Tuesday from 3:00 P.M. to 5:00 P.M., Wednesday from 10:00 A.M. to noon, and Sunday from 2:00 P.M. to 5:00 P.M.. There is no admission fee, but donations are appreciated.

From I-85 take Billy Graham Parkway south toward Woodlawn Avenue. Billy Graham becomes Woodlawn as it crosses Tryon Street at I-77. Follow Woodlawn several miles to Selwyn Avenue, which is at a traffic light just up the hill beyond Park Road Shopping Center. Turn left onto Selwyn; then go approximately .6 miles and turn left onto Ridgewood Avenue. Wing Haven is on the second block to the right.

WRAL Azalea Gardens

2619 Western Blvd., Raleigh, NC 27606
(919) 821-8555
www.wral-gardens.com

When gardeners think of TV, it's usually in a negative way, beginning with programming and ending with transmission towers. But if you live and garden in Raleigh or have visited the WRAL Azalea Gardens, you certainly will leave with warm feelings for the Capitol Broadcasting Company and WRAL-TV.

In 1959 A. J. Fletcher, Capitol Broadcasting Company founder, created the WRAL Gardens as a service to the Raleigh community. Three years after WRAL went on air as the first UHF station in Raleigh, the gardens, which surround the TV studios on Western Boulevard in Raleigh, opened to the public. The total area of the grounds is 5 acres, and the WRAL Azalea Gardens encompass ¾ of an acre. "I did it because I knew it would be beautiful," said Fletcher of his beloved gardens. "It was simply my way of paying a tribute to beauty for beauty's sake."

In 2003 the WRAL Gardens received the Tree and Landscape Conservation award from the 21st Annual Sir Walter Raleigh Awards for Community Appearance.

Beautiful hybrid azalea bushes bloom every spring at the WRAL Azalea Gardens.
WRAL AZALEA GARDENS

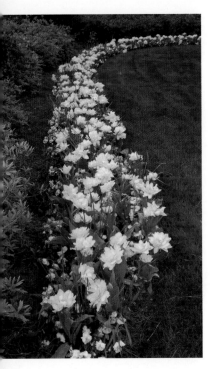

Demure pansies look up through a forest of yellow tulips. To the left of the border a few azaleas begin to open. WRAL AZALEA GARDENS

In the words of my gardening friends in Raleigh, as green space in the area becomes harder and harder to find, the WRAL Gardens offer a respite from traffic-ridden city streets, noise, and the miles of concrete necessary to serve the area automobiles. Stop at the gardens to get just a bit of peace.

The station supports the WRAL Azalea Celebration each October, giving away more than 10,000 azaleas to nonprofit organizations from all over North Carolina.

What about plants? There are forty-five different azalea varieties, along with other horticultural treasures such as *Acer palmatum* 'Fireglow'; six varieties of camellias, including *Camellia japonica* 'Kramer's Supreme'; rhododendrons; and crape myrtles.

The garden is open year-round from dawn to dusk.

Take the Raleigh Beltway (I-440), and look for the intersection of Western Blvd. and Avent Ferry Road, just across the street from North Carolina State University. The main entrance can be accessed via Centennial Parkway.

A pathway leads to the Elizabethan Gardens of Manteo.
ELIZABETHAN GARDENS

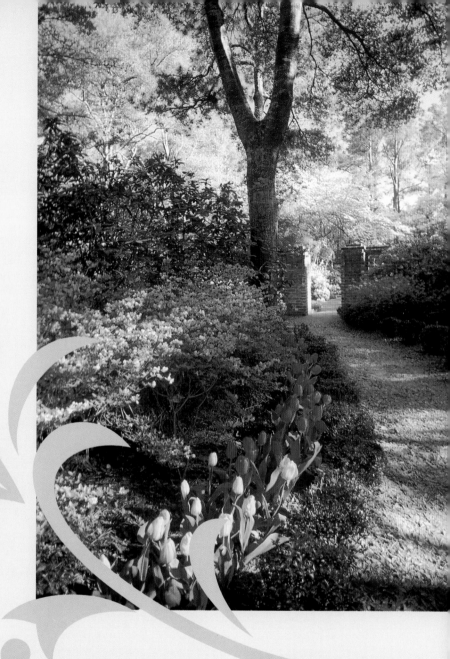

THE COASTAL PLAIN

Airlie Gardens

300 Airlie Rd., Wilmington, NC 28403
(910) 798-7700
www.airliegardens.org

Airlie Gardens burst upon the garden scene back in 1901. That's when its guiding light, one Sarah Jones, began a love affair with gardening, an affair that sparked when her husband, Pembroke, introduced her to his latest real estate purchase—150 acres of a natural maritime forest overlooking Wrightsville Sound, just north of Wilmington.

First Sarah talked Pembroke into building a modest little two-room vacation retreat beneath the giant oaks and pines, naming it Airlie. "One day," Sarah told a garden visitor, "while walking through my beloved woods I noticed a

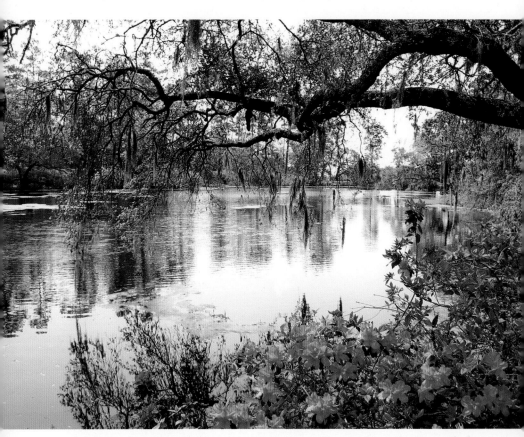

Airlie Lake, located in the center of a 67-acre property, is a manmade, 10-acre body of water lined with beautiful azaleas that bloom in early April. ARLIE GARDENS

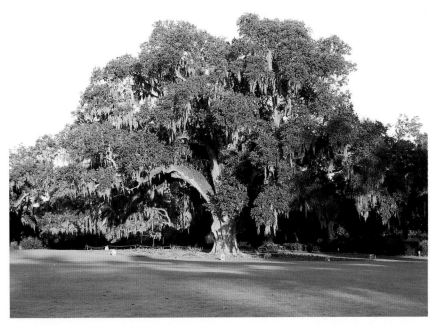

The Airlie Oak is a towering tree that dates to 1545 and is the highlight the Airlie lawn. ARLIE GARDENS

great clump of native pink azalea that down South we call wild honeysuckle. It was so lovely that I had it transplanted to a leafy moist spot near the house."

By 1940, Airlie had evolved into a chateau with thirty-eight apartments, a ballroom, and a banquet hall. Sarah recruited the gardener Topel, undergardener to the German kaiser, to the estate. There, working as a team, they added 500 oaks and 1,200 longleaf pines to the existing vegetation.

Today Airlie continues to be a most valuable cultural and ecological component of both New Hanover County and North Carolina history. In 1999, thanks to a grant from the Clean Water Management Trust Fund, the commitment of the New Hanover County Commissioners, the cooperation of the previous owners, and most of all the continued support of local residents, the county purchased and restored Airlie's present 67 acres of gardens.

Among the sights are thousands of azaleas in the spring and equally numerous camellias dotting the winter landscape. A classical Italian pergola was built in the early 1900s of coquina, a coarse-grained and porous limestone chiefly composed of shell fragments. The Airlie Oak is a towering tree that dates back to 1545 and is today the centerpiece of flowerbeds and the Airlie lawn. For a bit of romantic history, visit the Mystery Grave, the burial spot of an eighteenth century gentleman who took the name "John Hill."

According to local legend, he had been one of Napoleon's twelve marshals before emigrating to this country.

The gardens are open Tuesday through Sunday from 9:00 A.M. to 5:00 P.M. There is an admission fee.

The gardens are located on Airlie Road, 2 miles west of Wrightsville Beach.

Elizabethan Gardens

1411 National Park Dr., Manteo, NC 27954
(252) 473-3234
www.elizabethangardens.org

It was once a ten-hour trip from Ashville to the Outer Banks, but today the journey is much faster, thanks to new highways that connect one of the state's brightest vacation spots to the rest of the Carolinas. One of the best reasons for making a visit—in addition to the sand, wind, and tide—is the Elizabethan Gardens at the eastern edge of Roanoke Island. When you enter through the wrought-iron gates into the brick gatehouse, you enter another time, conjuring expectations of Italian countesses and Shakespearean characters walking by your side.

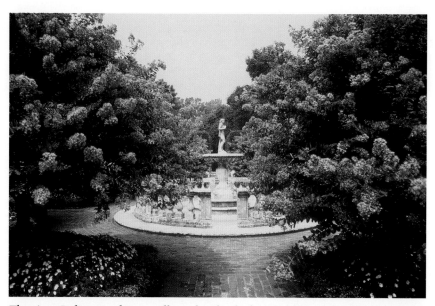

There's an Italianate edge to walking the Elizabethan Gardens, partially because of the beautiful statuary donated by John Hay Whitney. But the flowers, with the light and great soil, have that special glory too. ELIZABETHAN GARDENS

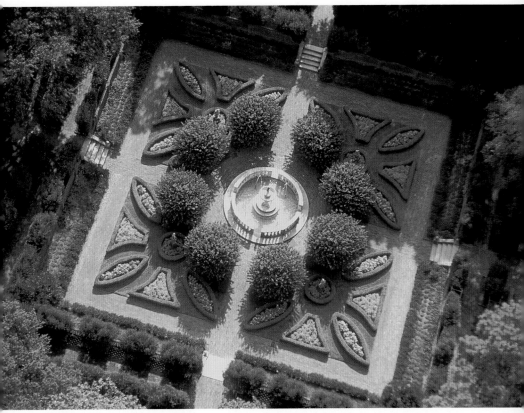

Looking down on the beautifully designed formal garden of clipped hedges, stunning annuals, formal statuary, and wonderfully constructed paved walkways. ELIZABETHAN GARDENS

As a memorial to the first English colonists who arrived in America from 1584 to 1587, the gardens mix history, mystery, and fantasy in a most sophisticated fashion. In 1951 the Garden Club of North Carolina adopted the Elizabethan Gardens as a special project. As an added incentive, in 1952 the Honorable John Hay Whitney donated an outstanding collection of European statuary and garden ornaments. By 1953 land was leased from the Roanoke Island Historical Association to begin building an English pleasure garden, and the internationally acclaimed landscape firm of Innocenti and Webel was commissioned to design the Elizabethan Gardens.

In addition to looking at the plants specifically chosen to excel in the gardens' green sand—sandy soil mixed with compost, leaf mold, and organic matter—also check out the Elizabethan gazebo, built of stucco and timber with a thatched roof provided by a master thatcher who came from Ireland to do the job. The gazebo provides a lovely view of the Roanoke Sound.

At the garden's perimeter, look for an enormous southern magnolia (*Magnolia grandiflora*) and ancient live oaks (*Quercus virginiana*), including a huge 400-year-old specimen of great stature and beauty.

There is an admission fee. The gardens are open twelve months of the year, usually from 9:00 A.M. to dusk, though there are special hours on Sundays in June, July, and August. They are closed on Thanksgiving, Christmas Eve, Christmas Day, and New Year's Day.

To drive to the gardens from most of the state, take U.S. Route 64 east from Raleigh toward the Outer Banks. Continue east until you reach Manns Harbor and cross the Croatan Sound on Virginia Dare Bridge (Route 64 Bypass). Turn left on Route 64 and continue 3 miles past Manteo to Fort Raleigh National Historic Site and the Elizabethan Gardens.

Orton Plantation Gardens

9149 Orton Rd. SE, Winnabow, NC 28479
(910) 371-6851
www.ortongardens.com

Orton Plantation is located about halfway between Wilmington and Southport on the west bank of the Cape Fear River, on land first settled in the early 1700s. Orton was a leading rice plantation. Though the quantity of rice grown was not high, its quality was, and for years many southern planters used it as seed. The cultivation of rice on the eastern seaboard continued until the end of the nineteenth century. Today the old Orton rice fields are maintained as a wildlife sanctuary.

Over the years the property passed from hand to hand, until one James Sprunt LLD bought the land and presented it to his wife, Luola. In 1910 Mrs. Sprunt added wings to the old house and then began to design and plant gardens. She constructed terraces and planted scores of azaleas and rhododendrons, along with a wide variety of shrubs. Today Orton is still owned by descendants, and though the grounds are open to the public, the house remains a private residence.

Besides azaleas and rhododendrons, other plants growing at Orton are camellias, crape myrtles, hydrangeas, daphnes, dogwoods, and many flowering annuals. For gardeners, a nursery sells a wide variety of the plants that grow on the grounds. Orton also specializes in a number of carnivorous plants.

A number of feature films have been shot at Orton, including *Firestarter*, *Crimes of the Heart*, *The Road to Wellville*, *Lolita*, and *Divine Secrets of the Ya-Ya Sisterhood*.

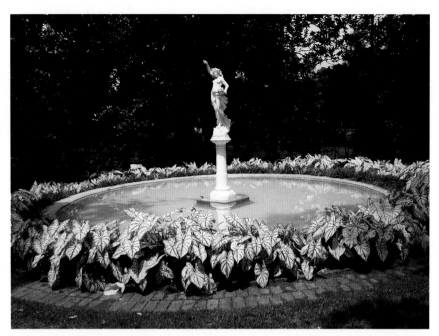

The gardens of Orton Plantation contain a wide variety of plants ranging from rho-dodendrons to dogwoods to many tropicals. The circle of caladiums here encloses a reflecting pond while a marble nymph throws petals to the winds. DR. JEAN B. GEARHART

The gardens are open March through August from 8:00 A.M. to 6:00 P.M. and September through November from 10:00 A.M. through 5:00 P.M. They are closed onThanksgiving and from December through February. There is a small admission fee.

Orton Plantation is located on NC Route 133, 18 miles south of Wilmington and 10 miles north of Southport.

Poplar Grove

10200 U.S. Route 17 N, Wilmington, NC 28411
(910) 686-9518
www.poplargrove.com

Instead of King Cotton, Poplar Grove Plantation owes its success to the peanut. Because of Professor G. W. Carver, more farmers in North Carolina started planting peanuts instead of cotton, and today peanuts are North Carolina's fifth-largest cash crop. Poplar Grove is a living salute to the importance of this crop in American agriculture in addition to being a beautiful example of a

Poplar Grove Plantation owes much of its history to the peanut, and the manor house is listed on the National Register for Historic Places. Built in the Greek Revival style, the house is a salute to the forms and ornaments of ancient Greek architecture.
POPLAR GROVE

working plantation, including a manor house, grounds, gardens, and the coastal waterways of the state. Built in 1850, the Greek Revival style house and its surrounding 628 acres supported the family and up to sixty-four slaves, working at the daily chores of weaving, spinning, making baskets, and eventually growing peanuts.

Poplar Grove has a special dye garden in front of the weaver's studio, best seen during the summer. The dyes produced from the leaves, bark, or roots provided many of the colors found in the textiles of the day.

The 63-acre Abbey Nature Preserve has a 2 1/2-mile nature trail winding through woods and crossing over the Mill Pond. The preserve, once the original site of Poplar Grove's gristmill, is now part of the North Carolina Birding Trail system and is a great way for the visitor to meet nature on a firsthand basis.

Listed on the National Register of Historic Places, Poplar Grove Plantation hosts a number of highly recommended annual events, including Halloween hayrides, a student art showcase, an herb and garden fair, and a Christmas open house.

Poplar Grove is open February through December, Monday through Saturday from 9:00 A.M. to 5:00 P.M. and Sunday from noon to 5:00 P.M. The plantation is closed on Easter, Thanksgiving, and from mid-December until the end of January. There is a small fee for house tours, but admission to the grounds is free.

Poplar Grove is 6 to 7 miles from the I-40 exit onto I-140. Take Exit 416B, U.S. Route 17 north (Topsail Island, New Bern), and stay straight to get on Route 17 north (Topsail Island, Jacksonville, New Bern). Go through one stoplight at Futch Creek Road. Poplar Grove will be on the right.

Tryon Palace
610 Pollock St., New Bern, NC 28560
(252) 514-4933
www.tryonpalace.org

Fourteen acres of beautifully cared-for gardens surround the home of North Carolina's royal governor William Tryon. Originally built between 1767 and 1770, this first permanent capitol of the colony of North Carolina was designed by John Hawks, an English architect. Hawks chose the Georgian style, echo-

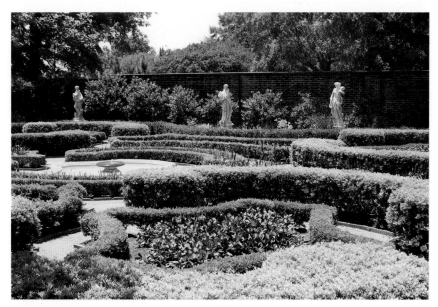

Tryon Palace consists of 14 acres of beautifully tended gardens surrounding the rebuilt home of North Carolina's royal governor William Tryon. The garden above reflects the careful design so popular in eighteenth-century England. TRYON PALACE

ing many fashionable houses in the vicinity of London, an approach that demanded symmetry throughout the design. Tryon Palace was thought to be the finest public building in the American colonies.

In 1794 Raleigh was named state capital, and space in the palace was rented out for a Masonic lodge, a private school, and a boardinghouse. In February 1798, fire started in the cellar with the combustion of stored hay. The main building was quickly destroyed, but the kitchen and stable offices survived the blaze. The kitchen was demolished early in the nineteenth century, but the stable offices survived.

Jump to the 1930s and a plan to restore North Carolina's first capitol. But the war intervened and time passed until 1944, when Mrs. James Edwin

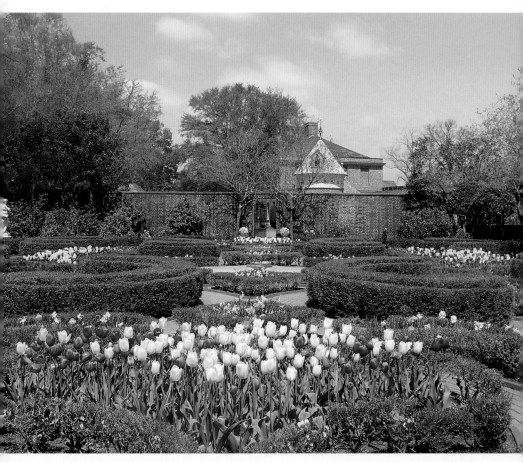

While the clipped hedges and the architectural design of the gardens at Tryon Palace can be appreciated year-round, the flowers of spring add a special touch after the chills of winter have passed. TRYON PALACE

Latham, a Greensboro resident and native of New Bern, challenged the state of North Carolina to join her in restoring the palace. Obviously, the effort was worth the result.

Regardless of the time of the year, the gardens are truly lush and lovely. With its burgeoning bulbs in spring, flowering fruit trees, shrub hedges, perennials and annuals on display (often with designs favored by the Victorians), sculpture, walls, and buildings, Tryon Palace is a joyful place to visit.

Because the gardens and grounds of Tryon Palace are so carefully maintained, any time of the year is a good time to visit. The various exhibits are open Monday through Saturday from 9:00 A.M. to 5:00 P.M. and Sunday from 1:00 P.M. to 5:00 P.M. The last guided tour of the palace begins at 4:00 P.M. daily. From March 1 to May 31, the gardens are open until 6:00 P.M.; from June 1 through September 5, until 7:00 P.M.; from September 6 to October 31, until 6:00 P.M.; and from November 1 through February 28, until 5:00 P.M. There is an admission fee.

Take I-95 north to Route 70 east to New Bern. Take the Trent Road/Pembroke exit, and turn left at the light. Turn right at the third light (Broad Street) and then turn right on George Street. The palace will be in front of you and the Visitor Center is at the end of the block on the right. To reach the visitor parking lot, turn right on Pollock Street, then left on Eden Street; the parking lot is on your right.

Wilson Rose Garden

1800 Herring Ave. (NC Route 42E), west of U.S. 301, Wilson, NC 27894
(252) 399-2261
www.wilsonrosegarden.com

Roses love heat, and some of the most brilliant rose gardens can be found in the Deep South. So the idea of starting a public rose garden in Wilson seemed natural.

In April 1992, in answer to public requests for a master plan to include some gardens, Rufus Swain presented the idea to the Wilson Parks and Recreation Department. His plan got an enthusiastic response, and Swain was appointed to the commission and asked to chair the project. After two years of planning, the rose project was submitted to City Council and approved.

Zelenka Nursery donated the plants for the first four beds, with the initial 120 plants set out in the spring of 1995. Two hundred more roses followed in 1996, 600 more in 1997, and 100 in 1998. Then a pergola was built, sponsored

The Wilson Rose Garden has been called one of North Carolina's best-kept secrets. In response to the roses such as these, the All-American Rose Selections have presented the garden with a maintenance award. JOHN SHELDON

The bench in the photo above lacks only a contented visitor reading a good book while the sweet smell of roses fills the garden. JOHN SHELDON

by the Garden Department of the Wilson Woman's Club, the first group to pledge support to the project, with donations of $150,000 received to date.

Currently, the garden contains more than 1,200 rose plants of 180 different varieties, including old garden roses, English roses (David Austin roses), hybrid teas, floribundas, grandifloras, climbing roses, miniatures, and shrub roses. Today plans are under way to increase their number. And for contemplation of the roses, seventeen benches and eight picnic tables have been installed, along with four wrought-iron arbors, seven trellises, a small pool, and the main fountain. The Rose Garden won an award for outstanding maintenance from All-America Rose Selections (AARS) in 2002.

The garden is open to the public daily from dawn until dark. Admission is free.

The Wilson Rose Garden is easily reached from I-95 north, exiting at Kenly onto U.S. Route 301 north, then exiting on NC Route 42. Turn left from the exit ramp, go to the stoplight, and turn left to the Rose Garden. From I-95 south, exit onto U.S. Route 301 north, exit onto NC Route 42. Turn left from the exit ramp, go to the stoplight, and turn left to Rose Garden.